CAPTURING LIGHT IN
ACRYLICS

JOHN HAMMOND WITH ROBIN CAPON

BATSFORD

For Mum

Acknowledgements

I would like to thank Robin Capon for his skill and dedication in making every stage in the production of this book, from conception to completion, such an enjoyable task. My thanks also to Chris Chard, who has been photographing my paintings with such care for a number of years, and to David and Carolyn at Causeway Framing. I am grateful to everyone at the various galleries that have exhibited my work, particularly the John Noott Galleries at Broadway in Worcestershire; Marine House at Beer in Devon; and Montpellier Contemporary Art at Stratford-upon-Avon in Warwickshire. Special thanks to Peter Burridge for his support, guidance and friendship since our first meeting. And lastly, but most significantly, a big thank you to all those admirers, buyers and collectors of my work for making my chosen path such a delightful one to follow.

First published in the United Kingdom in 2004
This paperback edition published in the United Kingdom in 2006 by
Batsford
151 Freston Road
London W10 6TH

An imprint of Anova Books Company Ltd

Copyright © Batsford
Text © John Hammond and Robin Capon
Images © John Hammond

ISBN-13: 9780713490275
ISBN-10: 0 7134 9027 6

A CIP catalogue record for this book is available from the British Library.

10 9 8 7 6 5 4 3 2 1

Reproduction by Anorax Imaging Ltd, Leeds
Printed and bound by Kyodo Printing Co Pte Ltd, Singapore

This book can be ordered direct from the publisher at the website:
www.anovabooks.com, or try your local bookshop

Distributed in the United States and Canada by Sterling Publishing Co.,
387 Park Avenue South, New York, NY 10016, USA

PAGE 1: *Detail of Shaded Corner, Provence Orchard,*
55 x 60 cm (21$\frac{1}{2}$ x 23$\frac{1}{2}$ in)

PAGE 2: *San Moise, Venice,* 90 x 80 cm (35$\frac{1}{2}$ x 31$\frac{1}{2}$ in)

CONTENTS

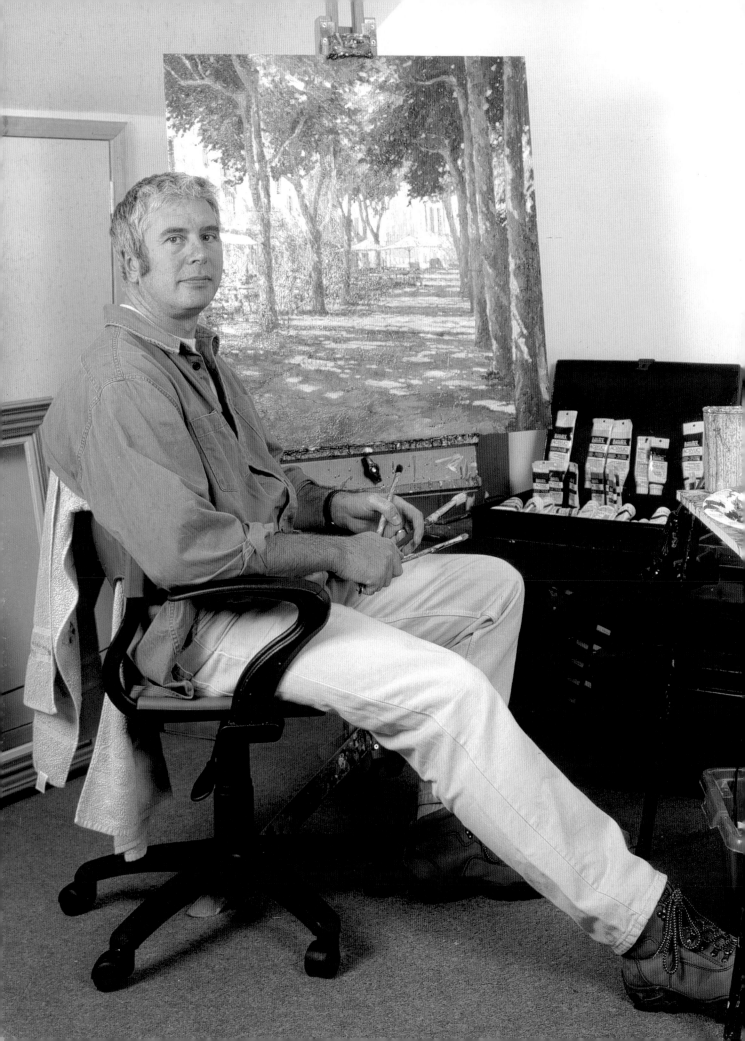

INTRODUCTION

I have always had a passion for drawing and painting. I can remember in my childhood, both at home and at school, being encouraged to explore different styles and mediums, and this was the way that I gradually became aware of the many possibilities that painting offered.

In November 1979 I went with my father to see the celebrated exhibition of Post-Impressionism at the Royal Academy of Arts in London. Standing in this gallery, surrounded by the fresh, original and very evocative works of Bonnard, Monet, Sickert, Van Gogh and many other fine painters, I felt totally inspired. I was particularly struck by the ability of these artists to create such a powerful sense of place and mood, and equally moved and excited by their exuberant concern for colour, texture, atmosphere and, most importantly for me, light.

In the next few years, first at Wimbledon School of Art and then at Bath Academy of Art, I continued to explore and experiment, sometimes losing my way and sometimes taking a step forward. It was at this time that I met my wife-to-be. She is still, and always will be, my most valued friend, adviser, assistant and critic. After leaving college I spent a number of years earning a living in various ways, some of which called heavily on my artistic talents, others less so. All the while I continued to develop my style and technique, trying different mediums and, equally significantly, studying the work of artists I admired. Painting is, after all, as much an intellectual skill as a matter of developing practical techniques.

7

John Hammond
in his studio

John Hammond painting on location

Finding different galleries to exhibit my work was a task that seemed rather daunting at first. However, I soon began to attract favourable responses, and now was the time, I told myself, to make the break. There was an opportunity to change the balance of my life from working to pay the bills and painting in my spare time, to dedicating myself to painting full-time. It was during this period that I started using acrylics. They seemed made for the way I wanted to paint and I found them quite liberating. For me, a big advantage of acrylics was that I could work quickly while maintaining complete control as I built up the depth of texture and colour I had been looking for.

With the luxury of time to paint all day and every day my painting was going from strength to strength. I was now travelling more, seeing new subject material and new ideas everywhere, and becoming increasingly enthusiastic about the direction my work had taken. My aim in painting is to communicate the feeling of a moment, and the things that define the moment for me are those temporary, transient qualities, the greatest of which is light. Above all, I consider myself a painter of light.

Today, I continue to travel and paint with as much enthusiasm as ever. Whether in the studio or out in the landscape facing the challenge of capturing that fleeting moment, I am happy to say that I still feel that same sense of excitement that I felt twenty-five years ago. I am now well supported and represented by a number of galleries, and the opportunity this gives me to meet and talk to visitors at my regular solo exhibitions is one that I much appreciate and enjoy. It is here that I am able not only to receive the feedback that I value, but also to share some of my thoughts and experiences.

Similarly, by explaining my methods in some detail and offering other ideas and suggestions, my aim in this book is to share my knowledge of acrylic painting and the benefits which I believe it has for capturing light and mood in a subject. I am very aware that my approach is something I have evolved over a lengthy period of time to suit my particular way of looking and interpreting. But I hope it includes aspects and techniques that are helpful and inspirational, and that you too will enjoy exploring the versatility of acrylics, whatever subjects and styles interest you.

Golden Field,
26 x 30 cm (10^1/$_2$ x 12 in)
Exploring any landscape will provide new experiences and challenges, with fresh sights and feelings to be captured.

9

1 PRACTICAL CONSIDERATIONS

It was the Abstract and Pop artists of the 1960s who first explored the potential of acrylic as a fine art painting medium. But it wasn't long before the strengths of this exciting, new type of paint were recognized by other artists too, and it was soon being used for a wide variety of subjects, in work that explored many different painting techniques and styles. Today, following advances in the manufacturing process, there are several forms of acrylic paint to choose from, including liquid acrylics and high-viscosity brands, and there is a similarly extensive range of colours. Given this choice and the particular qualities of the medium, it is not surprising that it is now so popular.

Many artists prefer acrylics because they are a very adaptable, forgiving type of paint – one that allows you to work without inhibitions. With acrylics there are no 'rules' or set procedures to follow: you are free to choose an approach and a range of techniques that suit the way you want to paint. Here is a medium that is excellent for capturing qualities such as light and mood, indeed for expressing observations and feelings about any subject in your own, personal way.

Of course, the ability to apply and manipulate paint exactly as you wish will depend on first mastering the basic practical and technical considerations. These include getting to know the nature of acrylic paint and how it will respond in different circumstances; experimenting with colour and colour mixing; and gaining experience with various techniques. In this first section of the book I will be looking at these important aspects in some detail.

Winter Light,
Noss Mayo,
90 x 80 cm (35¹/₂ x 31¹/₂ in)

A Versatile Medium

One of the most influential painters in acrylics is David Hockney, who began using this medium in 1964 on his first visit to California. What he particularly liked about acrylic paint was the quick drying time. Later, in the exhibition catalogue for his show at the Whitechapel Art Gallery in 1970 (*David Hockney: Paintings, Prints and Drawings*), he describes how, when he painted in oils, he always had to work on at least three or four pictures at once – since oil paint is slow-drying, the only way he could continue to paint continuously day after day was to switch from one painting to another. But, as he goes on to explain, when he started to paint in acrylics he was able to concentrate on a single picture and develop the idea from start to finish without interruption.

My experience was very similar. I started with watercolour, but much as I admire this medium and am impressed by many of the watercolour paintings that I see at exhibitions, it does not suit the way I want to work. With a watercolour you can only go so far: if you do more the painting becomes laboured and the translucency and freshness are lost. I found this restricting, because I always wanted to develop aspects such as texture and depth in my paintings more fully. My frustration with watercolour led me to try oils. But here, like David Hockney, I was hampered by the drying time. Having to stop and wait for the paint to dry created a hindrance to my natural working process that I found unacceptable. Painting in acrylics seemed the obvious solution to these problems.

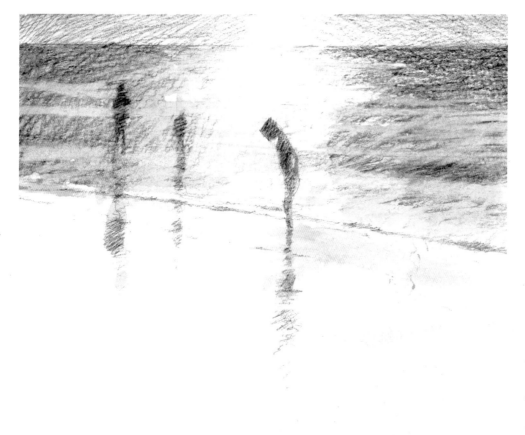

Figures on the Beach, location sketch,
12.7 x 16 cm (5 x 6¹/₂ in), pencil and acrylic wash
The rapidly changing light and the strong incoming tide meant that the feel of the moment had to be recorded quickly. These 'thoughts on paper' are invaluable as memory triggers for studio work.

**Across the Lagoon,
Afternoon Light,
location study,**
30 x 30 cm (12 x 12 in)
acrylic on 300 gsm Langton
watercolour paper
*Here, a break in the cloud
sent a spotlight of
illumination onto the
perfect subject. This study
carries all the information
required for further
development.*

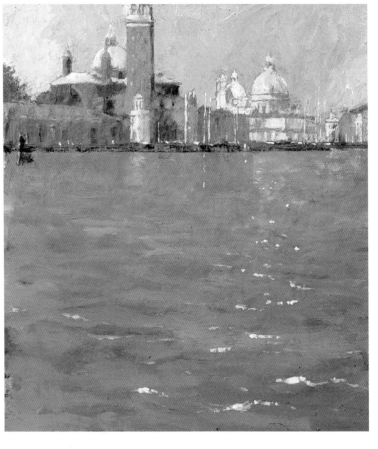

**Across the Lagoon,
Afternoon Light,**
30 x 30 cm (12 x 12 in)
*Working from my memory
of the scene and the study
above, I was able to refine
the image and develop this
studio painting. The
highlights on the water
were applied with thick
opaque marks, contrasting
with the translucent glazes
used to suggest the
reflections of the sunlit
buildings.*

13

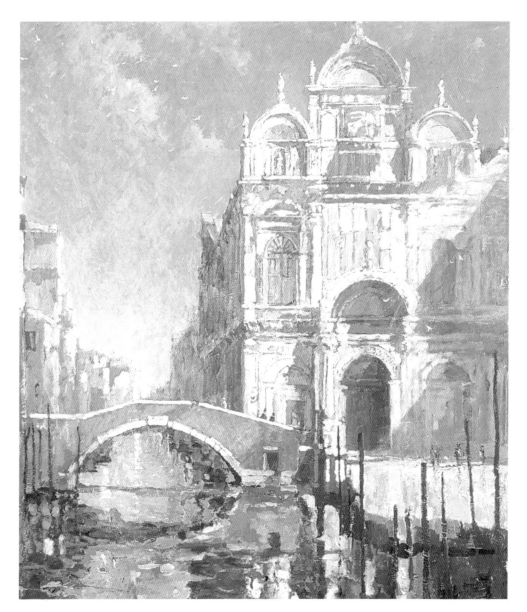

Scuola di San Marco,
Morning Walk,
80 x 77 cm (31¹/₂ x 30¹/₂ in)
To convey the depth and
complexity of the
architectural detail of this
fine building I used
sculptural impasto
brushwork interlayered
with delicate glazes.

14

I immediately enjoyed working with acrylics. The quick-drying nature of this medium meant that now I could keep painting and painting until I wanted to stop. Because of the degree of control that acrylics allowed, I could dictate the pace and development of the picture, rather than thinking that I must work within certain bounds set by the medium. For instance, I didn't have to worry about reserving the whites, which was always a concern in watercolour, or painting fat over lean (slower-drying unthinned oils over quicker-drying thinned ones), which is the

accepted way of building up an oil painting. Instead, because of the versatility of acrylics I could add light areas at any stage in the painting and work glazes over impasto areas, or vice versa, without fear of the paint surface lifting or crazing. And, as I gradually discovered the extraordinary potential of this medium for different paint-handling effects, so it enabled me to achieve exactly the depth of colour and quality of light I wanted for each subject I tackled.

What is Acrylic Paint?

Like all other artists' colours, acrylic paint consists of pigment (natural and synthetic finely ground colour particles) and a binder. The binder holds the pigment particles together and fixes them into a continuous area of colour as the paint dries. In the case of acrylics the binder is a synthetic resin which has excellent adhesive qualities and which, although water-soluble when wet, will give a flexible and water-resistant film when dry. Most acrylic colours have a high lightfastness rating and consequently they do not fade with age.

Acrylic paint dries by evaporation. Consequently the actual rate of drying depends in part on the ambient temperature and humidity. In normal circumstances the paint dries quickly: thin washes of colour will take just a few minutes to dry. This can be a distinct advantage, especially if you like painting on the spot and want to capture a scene speedily, before the light changes. On the other hand, if you need to slow down the drying time, this can be done by adding a retarding medium to the paint.

Speed is an important factor in the way that I work and, as I have explained, this is one of the main reasons why I paint in acrylics. Personally I never use retarding mediums or other devices to slow down the drying time. In fact I quite often go to the opposite extreme and look for a hair-dryer so that I can speed up the drying process even more! This is because all my paintings are concerned with capturing a particular moment in time, with the various associated considerations regarding light and mood that this implies. Even when I am in the studio my aim is to paint in the *plein air* manner – as if out of doors. This keeps the paintings spontaneous and prevents them becoming overworked and so destroying the 'impressionist' quality that I like to achieve.

For me, another big advantage of acrylic paint is that it is a very straightforward medium to use. Whichever way the paint is applied I know there won't be some unforeseen reaction, so I can concentrate on creating the effects I want rather than having to worry about technical matters. Also, there is a freedom in knowing that if a colour is wrong or I want to adjust a mark, it can be quickly painted over. And, because most colours are opaque, it is possible to introduce light areas at any stage in the painting instead of having to plan the composition and reserve the light areas in advance.

15

16

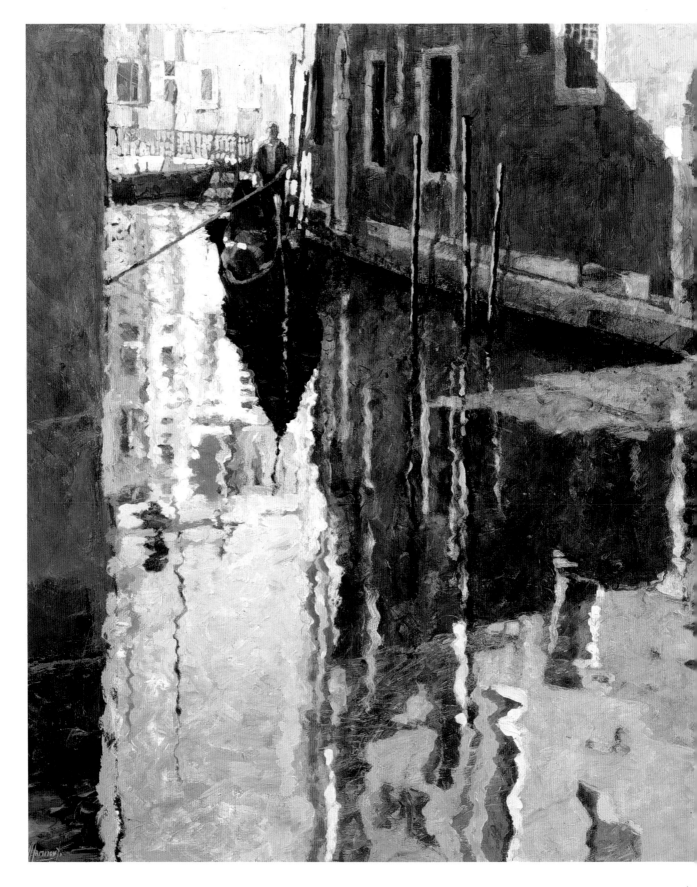

Exploring Acrylics

As well as colour, which is obviously a very important consideration in painting any image or effect, there are several other paint qualities that can be helpful in interpreting a subject successfully. These include the consistency of the paint, the way it is applied to the paint surface, and opaqueness and transparency.

How thickly or thinly you apply the paint is partly a matter of individual preference and painting style, and it will be partly influenced by the subject matter and the mood you are trying to create. Acrylic paint is very versatile: it can be thinned to make washes or glazes of colour and handled rather like watercolour, or it can be applied directly from the tube to produce texture and impasto effects – and there are many other possibilities in between. Also, you will find that the consistency of the paint varies from one brand to the next, and it can be modified by adding different acrylic gels and mediums.

Some artists mix their paints with water to make them more workable or to reduce the intensity of the colours. Occasionally I paint in this way when I want to make a quick colour study for reference, but generally I like a high-viscosity paint that I can use in the consistency that it comes from the tube. My preferred brand is Liquitex.

Whether thick or thin, acrylic paint can be applied in all kinds of ways, from flat washes to scumbling, stippling and so on. I will usually employ a number of techniques in the same painting in order to convey the contrasting qualities and characteristics of different objects. *The Gondolier* (opposite) demonstrates these points. Here, for instance, the foreground water was built up with many layers of glazes to establish the required depth of colour, while in contrast the corridor of light in the background was created with heavy impasto work. Painting techniques are discussed in detail later in this section (see pages 34–35).

Another quality you can exploit in your paintings is the contrast between opaque and transparent colours. Most acrylic paints are fairly opaque, so they will give quite solid areas of colour, but others are semi-opaque or transparent, thus allowing some of the underlying colour to show through. If you dilute a colour, it normally becomes more translucent. With most brands the tubes are marked to indicate whether the colour is opaque or transparent. In the Liquitex range, for example, cadmium red light is opaque, cobalt blue is semi-opaque and Hansa yellow light is transparent.

17

The Gondolier,
80 x 90 cm (31¹/₂ x 35¹/₂ in)
*An approaching gondola
gently disturbs the mirror-
like reflection of richly
coloured Venetian
buildings, giving movement
to this exploration of the
play of sunlight on
different surfaces.*

Materials and Equipment

There is an extensive range of paints, brushes and other materials available for acrylic painting. Bear in mind that the materials you choose will influence the nature and success of your work, so it is well worth comparing information from different manufacturers and experimenting with several types of paint and painting surface to find those that will help you achieve the best results .

Paints

Most art materials shops stock well-known brands such as Daler-Rowney, Winsor & Newton, Liquitex, Schmincke, Lascaux and Golden. Some of these manufacturers produce several varieties of acrylic colours, including both artists' and students' quality paints. For example, in the Daler-Rowney range there are Cryla Artists Acrylic Colours, which have a rich buttery texture, and also System 3 colours, which are more fluid in consistency. Artists' quality paints are well worth the extra expense. Made from the finest pigments, these paints give richer colours and have better handling characteristics than the cheaper students' quality alternative.

Once you have found a brand and range of paints that you like and have gained some experience with them, you will be able to exploit the particular qualities and potential of the different colours and so create the effects you want. I tried several brands before settling on Liquitex, which had just the right consistency for the way I like to work (using an approach similar to oil painting), as well as a range of pigments that suited me. In my view it is best to keep to a single brand of paints. Since the exact composition of the paint and the drying time, can vary quite

considerably from one brand to another, various problems may arise if acrylic products from different manufacturers are combined in the same painting.

Before starting any painting you will need to select a palette – that is, a range of colours to work from. Most artists use the same basic palette for every painting, perhaps adjusting it slightly if the subject matter requires it. My advice for setting out a palette is to use as few colours as possible. Only introduce a new colour if it is vital for the effect and impact you want. If you start with lots of colours it can lead to confusion and a temptation to combine too many colours when mixing, resulting in 'muddy' colours and perhaps disharmony in the overall colour effect. It is a mistake to think that the more colours you have on your palette, the easier it will be to make a good painting.

The selection of colours for a palette is a personal choice which artists usually arrive at in a practical way, through experience and experimentation. Most artists use a palette that includes two reds, two yellows and two blues (the primary colours), plus one or two favourite 'secret-weapon' colours that are pertinent to their particular subjects and techniques. This primary-colours selection has always been the basis of my palette, although I have gradually adjusted it over the years. For instance, I have replaced cobalt blue with Phthalo blue. The palette I currently use consists of titanium white, cadmium yellow light, cadmium yellow medium, cadmium red light, cadmium red medium, yellow oxide, Van Dyke red hue, light blue violet, dioxazine purple, cerulean blue, and Phthalo blue. All the paintings in this book were produced with this set of colours.

18

Shifting Sands,
30 x 30 cm (12 x 12 in)
*The brilliant reflected light
coming from the water was
painted heavily and
opaquely over a dark
underglaze. This allowed
me to keep the figures as
silhouetted shapes, by
painting the light that
surrounds them.*

*A selection of my paints,
with the main colours set
out ready for use on a
white palette.*

19

Brushes

I may use more than 30 brushes during a single painting session and in total I have about 80 in my studio. Of course it is possible to complete a painting with far fewer brushes, perhaps just one brush, but I like to work quickly and I rely on having a steady supply of clean brushes available. Clean brushes are important because they keep the marks pure and the colours fresh. So, when I want to change colour, rather than stopping to clean the brush, which inevitably means interrupting the painting process, I put it in a pot of water and choose a new one.

I start each painting session with two large pots of clean water: one for rinsing out brushes that I want to continue to use, and the other for used brushes that will be cleaned later. However, I never leave brushes standing in water for too long, because this may damage the hairs –hog brushes are especially susceptible in this respect. At the end of each session I clean all the brushes,

using warm water and a little mild detergent or liquid soap, and I empty the pots and refill them with clean water. Never let acrylic paint dry on a brush, because once dry it is not soluble again in water.

My brushes include flats, filberts, rounds and sables in a variety of sizes from 6.3 cm ($2^1/_2$ in) to 00. Mostly I use Winsor & Newton Artisan brushes, which are fairly robust and keep their shape well, but for areas where I don't want the brushmarks to show I choose soft sable brushes. I was taught always to work with the largest brush possible for a given area or effect in a painting, and this is something I try to remember. I find that using small brushes encourages fussy work. I like to use old brushes as well as new ones – a well-worn brush can be very handy for creating certain effects – and I sometimes trim the ends off sable brushes so that they give 'flatter' marks. You can see some of my brushes in the photograph of my studio below.

Clean brushes are important to the way I work, so I like plenty to choose from.

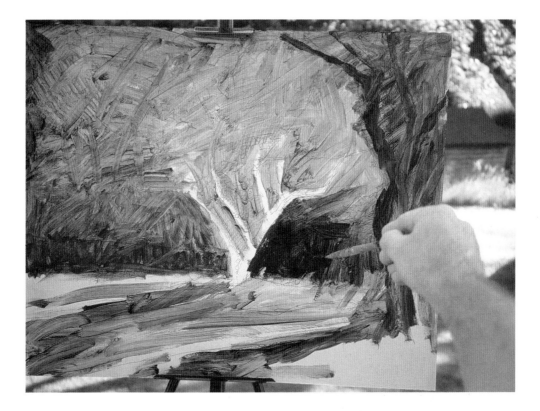

Supports

Acrylic paint can be applied to a variety of surfaces, including paper, cardboard, hardboard, MDF (medium-density fibreboard), canvas boards and canvas. Of course, each of these surfaces has its own qualities and potential for different approaches, so here too it is helpful to experiment with as many alternatives as you can to find out which ones feel right for you. The important point to remember is that acrylic will not adhere to any surface that is oily. Therefore avoid products such as oil sketching paper or canvases and canvas boards that have been prepared with an oil-based primer.

I use different types of paper and primed mountboard for my location studies, and prepared MDF for the studio paintings. I dislike painting on canvas or canvas board because I find the regular surface texture rather intrusive.

The first stage of a painting on prepared MDF. You can see some of the white acrylic gesso primer still showing through.

With the MDF, which is cut to size and prepared by applying two or more coats of acrylic gesso primer, I am able to create whatever kind of surface I need for a particular subject. I apply the primer with a large flat brush, allowing the first coat to dry before adding further coats. The back of the board can also be sealed with a coating of primer, to prevent warping. When I want a really smooth finish I sandpaper the gesso surface with a fine-grit paper, but generally I apply the primer heavily to build up the required texture. Usually I leave the board to dry out thoroughly overnight, ready to begin painting the next morning. The illustration on page 21 shows how the first stage of a painting is worked over the gesso surface.

Acrylic sketches using thin washes of paint, similar in approach to watercolour, can be made on stretched cartridge paper and various watercolour papers. Alternatively, when I want to apply the paint quite thickly, with little or no water, I often work directly onto unstretched heavy quality watercolour paper and, as in the location study shown on page 25, I sometimes choose acrylic painting paper. However, I find that the paint tends to slip on this kind of surface, so for more resolved studies I prefer to use paper treated with a coating of acrylic primer.

Palettes

There are some palettes that have been specifically designed for acrylics, such as the Daler-Rowney Stay-Wet palette, but various home-made alternatives can work just as well. Plastic, melamine and glass are good surfaces to use for palettes because they are non-porous, washable and easy to clean. A white surface is best. Placing a sheet of white paper under a glass palette, for example, will enable you to see the colours more clearly.

My palettes are inexpensive white plastic trays. I have several of them. The advantage of this surface is that when the paint dries I can simply peel it away as a single layer, so the trays are very easy to keep clean. At the end of a day's painting, to preserve the paint in a workable condition, I turn one tray upside down and place it over another. Inevitably, due to the way I work, I often have quite a lot of paint left over when I finish a painting, but this isn't necessarily wasted. Sometimes I use it for the underpainting of the next picture (see the section 'Underpainting', page 34), and sometimes I scoop it up before it dries and put it in an airtight container, such as a plastic film canister, for use later.

Tear-off paper palettes are useful when you want to work in an impasto technique, for the paper will absorb some of the moisture in the paint and so allow you to apply it in a thicker consistency, and thus with more control. Like me, you could also use various old scraps of watercolour paper for this purpose.

Acrylic Mediums

The versatility of acrylic paints can be increased even further by mixing the colours with one or more of the various acrylic mediums that are available. These include gloss and matt glazing mediums; flow improver (which increases the transparency of colours and the ease with which they can be brushed on); and texture gel (which thickens paint for impasto effects). The use of mediums will obviously make the painting process more complicated, so it is best not to experiment with them until you are fully confident with the basic painting techniques.

The only medium I use is gloss glazing medium, which I find ideal for making

transparent glazes. Mixing a glaze in this way requires some experience. Not only does the proportion of acrylic colour to glazing medium have to be just right, but you also have to allow for the fact that, because these mediums are milky white when liquid and become transparent only when dry, they will initially influence the colour you are mixing – for instance, a red glaze looks slightly pink until it dries. To achieve maximum transparency, glazes should be applied in broad, light strokes rather than attempting to work the colour into the surface. I may apply up to forty successive layers in this way to create the right effect in certain areas of a painting, and indeed glazes are an important feature in much of my work, adding depth, vibrancy and interest.

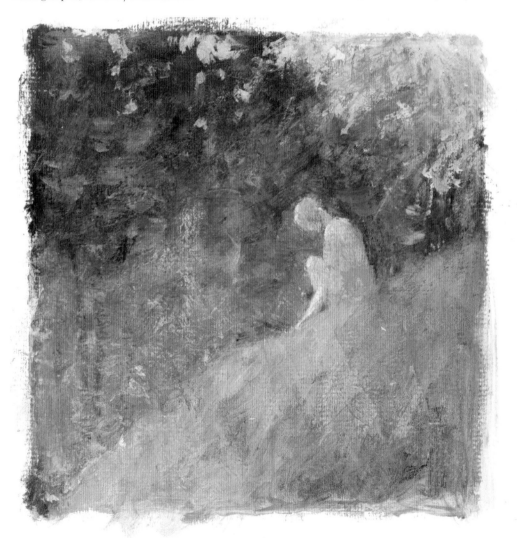

Small figure study using glaze medium. The textured acrylic painting paper was ideal for the many glazes that were necessary to achieve the intensity and depth of colour in this study.

23

Studio Equipment

I think it was Edouard Vuillard who said that the most important piece of equipment in the studio is the chair. Of course what he meant by this was that painting isn't just skill with the brush: it also involves a lot of sitting, looking and considering. So a comfortable chair is essential!

Other important considerations are the layout of the studio and the way it is lit. Whatever the studio space, some planning will help things run more smoothly. My studio is arranged so that all the essential materials are within easy reach while I am painting. I like everything to hand; I find nothing more frustrating than having to stop half-way through a painting to look for a particular colour or brush. I work at an easel, sometimes sitting, sometimes standing, and there is plenty of space for me to regularly view work in progress from a distance. I also have some spare frames available so that occasionally I can check how the painting will look when it is framed.

When they are bought and hung on a wall somewhere, most paintings are viewed for the majority of the time in artificial rather than natural light. Consequently, in order to keep the colours compatible with how they will be seen when the painting is sold, I prefer to paint in a combination of artificial and natural light. This also gives me more control over the lighting: I can increase or decrease it as necessary. For the artificial lights I use a mixture of Daylight bulbs (which give light over the entire visible spectrum, mimicking the effect of natural light) and ordinary light bulbs, which give just the right degree of warmth to the lighting.

24

I always take one or two sketchbooks on my painting trips.

Location Equipment

Generally the equipment for location work is governed by practical considerations rather than what is ideal. But wherever I go I normally carry a notebook and a pen, while for more organized painting trips I will also take sketchbooks and sketching equipment plus a camera and full kit of paints, brushes and ready-primed boards in a large canvas bag. This provides everything I need for brief sketches, colour studies and small location paintings. Usually the size is limited to 40.5 x 40.5 cm (16 x 16 in), but if I have a car available and can work reasonably near it, then larger-scale paintings are possible.

25

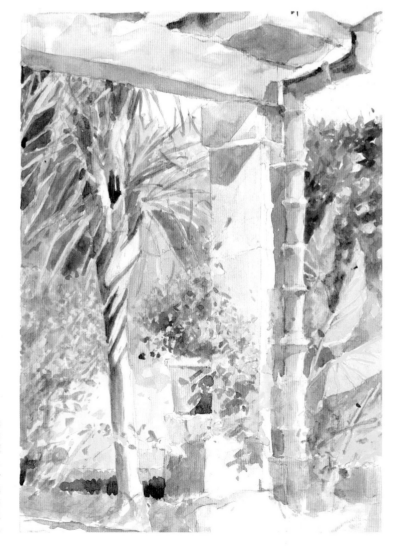

Location study painted in acrylic on Daler-Rowney System 3 linen-textured acrylic painting paper. Working on textured paper using paint diluted with water has to be a speedy process when painting in the Mediterranean sun.

Colour Mixing

Being able to capture what you feel is important about the subject matter and conveying the right mood and impact in a painting are qualities that depend to a great extent on a knowledge of colour and confidence with colour mixing. Mastering the many different aspects of colour and how these can be exploited in the painting process can seem a daunting task. But, as with brush techniques and other matters, it is largely a question of slowly gaining experience – learning from one painting to the next.

This is how I started to learn about colour – in fact, by beginning with black and white paintings and then gradually introducing colour. Something else I did was to study the palette of colours chosen for different paintings by some of the Impressionists and other established painters – basically tapping in to their extensive knowledge. Colour theory was another aspect that helped initially, and experimenting with various colour mixes. And now, with this experience and knowledge from my formative years to call on, I am able to respond to colour and create different colour mixes in a more intuitive, spontaneous way.

Observing Colours

Before starting a painting I always spend some time just looking at the subject and assessing how I want to interpret it and how various colours will help in this respect. This is particularly important with regard to capturing different light effects and creating the sort of atmosphere and mood I want for the painting. From this assessment I know which colours I am going to emphasize and the overall 'colour key' for the painting (that is, whether to use predominantly warm colours or cool colours) and thus I can set out my palette accordingly.

Whether a landscape or any other subject, it is easy to fall into the trap of thinking that you must faithfully reproduce and include every colour you see. By doing this you might well produce a very realistic painting but it will probably be one without personality and impact. Instead, you must decide which colours contribute to what you want to say about the subject and which detract from it. So don't be afraid to leave out some of the colours or make adjustments. Use colours that work for you.

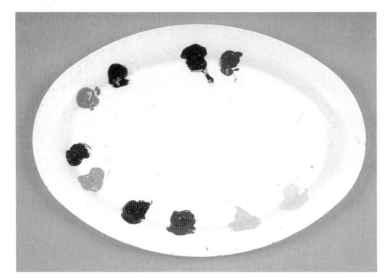

My palette, showing the sequence of colours that I normally use.

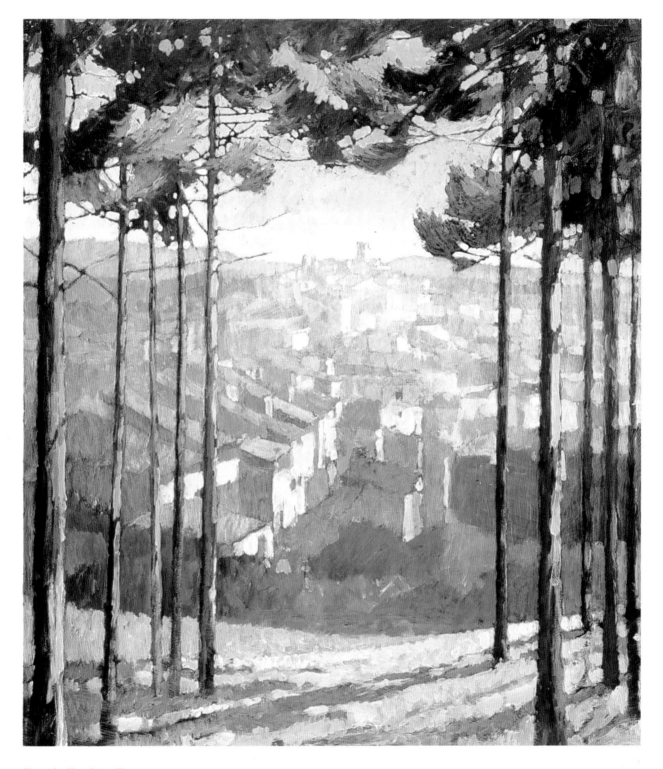

From the Tree Line, Tuscany,
90 x 80 cm (35¹/₂ x 31¹/₂ in)
*Here, I was impressed by the way the Tuscan valley mist
filters not only the tonal variations but also the intensity of
colour seen in the village below. I have used the foreground
trees, with their strength of colour and tone, to create great
depth in the painting.*

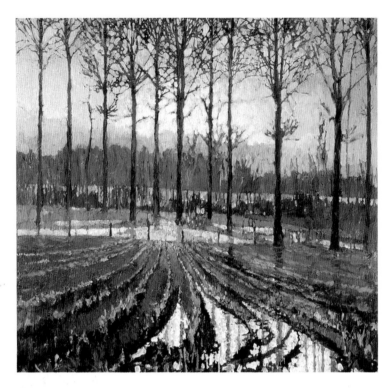

Colour Theory

28

As I have mentioned, a good way to gain confidence in using colour is to combine the practical business of mixing colours with a study of colour theory. The theory needn't be complicated – a knowledge of the basics is all that is required to understand what will happen when you mix certain colours on the palette.

Most artists use a limited palette, based on the three primary colours plus one or two colours that are more specific to their working methods and subjects. Further information on palettes is given on page 18. Artists usually choose a dark and a light version of each of the primary colours, as this gives greater scope for mixing colours of different tonal value and intensity. Theoretically it should be possible to mix most other colours by using two or perhaps all three primary colours. Obviously the amount of each colour used will influence the resultant mixed colour.

Initially, a reliable method to increase your knowledge of colour mixing is to set out a palette with a basic range of colours (perhaps similar to the colours I use, which are listed on page 18) and then experiment with different combinations. You could start by mixing one primary colour with another, first using equal amounts of each colour and then varying the amounts. The new colours, orange (made from red and yellow), purple (red and blue) and green (yellow and blue), which are known as secondary colours, can in turn be mixed with each of the primary colours to create further interesting colours, including various browns and greys.

Get to know your palette in this way, so that you appreciate how one colour will influence another. Using a limited range of colours will not only simplify the process of colour mixing and help you gain a good understanding of the different colours on your palette, it will also create a better overall colour harmony in

your paintings. Try to keep the colours as pure as possible – that is, uncontaminated by dirty brushes or other colours around them on the palette, and avoid mixing more than three or four colours together, as this tends to produce rather 'muddy' colours.

Usually when mixing a colour you will be trying to match it to one in your subject. Start by carefully observing the actual colour and note if this is modified by shadows, reflected colour from nèarby objects or other factors. What is the tone of the colour (its relative light/dark value) and its temperature

(whether it is a warm or cool colour)? From these observations you should be able to choose the basic colours for your mix, which you can then adjust accordingly if the colour needs to be a little darker, lighter, redder or whatever is necessary for the right effect.

Remember that each individual colour has to be considered in relation to the painting as a whole. Colours react with one another. In composing a painting you have to exploit the properties and relationships of different colours, contrasting and positioning them to gain the maximum effect.

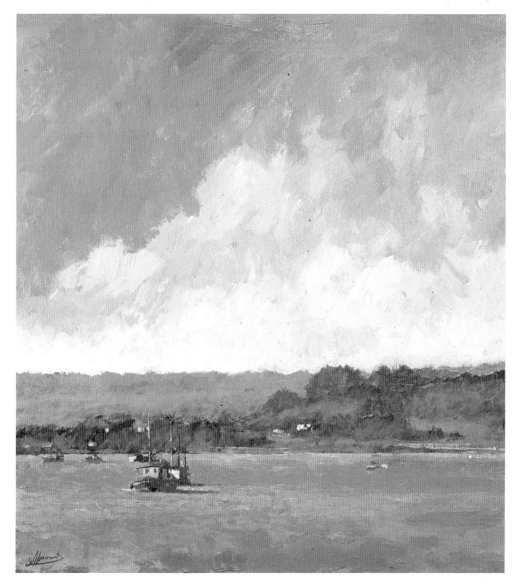

Pilot Boat at the Mouth of the Exe,
40 x 40 cm (15¹/₂ x 15¹/₂ in)
The strong sense of colour and tone in this subject was created by a low golden winter's sun. The intensity of the red boat, which was the main inspiration for the painting, is echoed in the russet trees beyond and in the underpainting glimpsed through the broken sky colour, adding a unity to the composition.

Mixing techniques

In my paintings I use three main techniques for mixing colours: physical mixing (that is, mixing colours together on the palette); glazing; and optical mixing.

When I mix colours on the palette I normally use the paint directly from the tube, in its thick, buttery consistency. I only dilute colours with water when I am painting on paper. However, you may want to work with broad, sweeping brushstrokes or fairly uniform areas of colour, and in this case you will need paint of a more fluid consistency. Adding water does help improve the fluidity of the paint but at the same time it reduces the intensity of the colour. You must be careful not to add too much water, as this will also dilute the binder and consequently affect paint adhesion.

The method I use to make paint thinner is to mix a small amount of acrylic gloss glazing medium with the colour, and when I want very diluted transparent glazes I add a lot of this medium. One of the advantages of using glazing medium as a diluent is that, being of the same formulation as the binder, it will not weaken it and so compromise adhesion. If I am diluting the paint just a little, then I usually add the gloss glazing medium after

I have mixed the colours together. But for very thin glazes I find it works best to dilute each colour first and then do the mixing. However, I prefer not to mix the colours too thoroughly, to ensure the new colour has some variation and interest when it is applied to the chosen surface.

In some paintings I combine the conventional methods of colour mixing with the use of small, interspersed marks of different colours that collectively suggest a single colour – a technique known as optical mixing. Intermingled red and yellow dabs of colour, for example, will produce an overall impression of orange. Again, this is a good method for creating a broken area of colour, perhaps in the foreground of a painting, which will contrast well with other areas handled in a less textural and vibrant way.

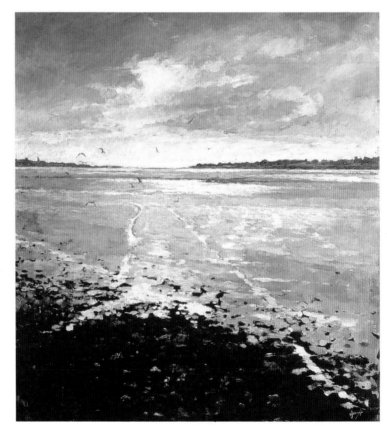

Into the Light, Topsham,
90 x 80 cm (35¹/₂ x 31¹/₂ in)
The intensity of light in this atmospheric estuary scene is captured through the use of high tonal contrast rather than extreme colour mixes.

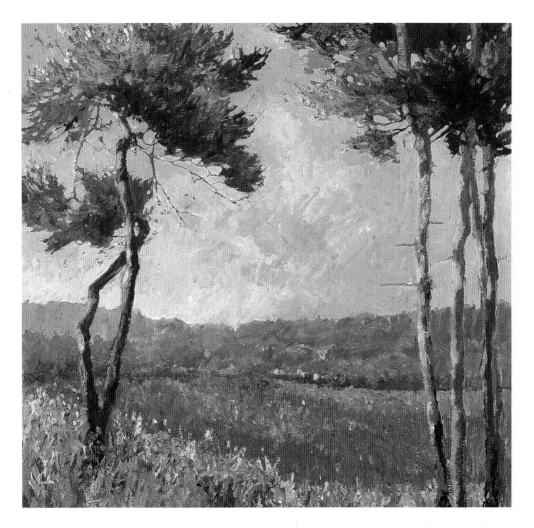

Making Colour Work for You

Every colour has the potential to create or contribute to a variety of effects, so the choice of colours and the way in which they are applied to the support must be considered very carefully. While colours are often descriptive, in the sense that they help interpret the characteristics and form of objects or areas within the painting, they also play an important part in suggesting depth and conveying a certain mood and quality of light. It follows that success in achieving the emphasis and impact you would like for a particular subject will depend on making colour work for you. And in turn this will rely on making the most of your experience in observing colour and colour mixing.

Those colours with a bias towards the blue part of the spectrum tend to recede in a painting, while the warm reds, oranges and yellows will advance. This is a quality that can be exploited, particularly in a landscape subject where you want to create a strong feeling of depth and space. I have used this technique in *Falling Light*, *Garfagnana* (above), combining it with contrasts in colour intensity between foreground and distant shapes, and specifically choosing colours that will convey a sense of the fading, pinkish light at the end of the day.

Falling Light,
Garfagnana,
40 x 40 cm (15¹/₂ x 15¹/₂ in)
As the sun's intensity drops, so does its bleaching effect on local colour. Consequently I chose an intense palette for this scene, in which the heat at the end of the day seemed to glow from the landscape.

Light is a feature in all my paintings and, therefore, as well as observing individual colours I am also instinctively noting the relative light/dark value of the colour – its tone. The way I interpret a certain quality of light relies to a large extent on manipulating the tonal contrasts in the subject and deciding how these should be juxtaposed within the composition as a whole. Furthermore tone, as an aspect of colour, is a means of suggesting space and depth, because subtle tonal variations appear distant while stronger tonal contrasts catch the eye and jump forward. As an aid to assessing the tonal values in a subject try looking at it through half-closed eyes. This helps to focus attention on the general lights and darks. Tone is covered in more detail in the next section, 'Interpreting Light' (see pages 47–75).

Flower Gatherers, Provence,
60 x 60 cm (23¹/₂ x 23¹/₂)
The introduction of pale blue and violet in the distant woodland gives depth and a feeling of scale to this image. As the flower gatherers quietly go about their work in the hush of the early morning mist they are dwarfed by the lofty tree canopy that covers them.

32

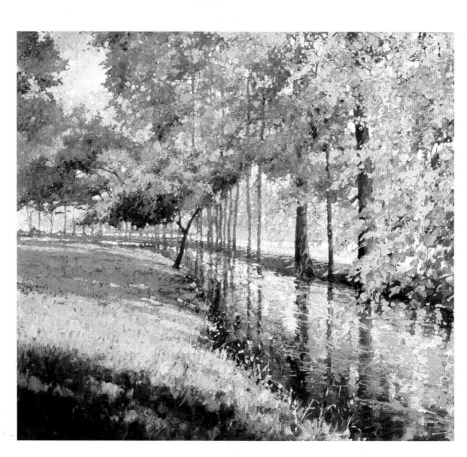

Gardon Reflections,
80 x 90 cm (31¹/₂ x 35¹/₂ in)
Close observation and careful colour mixing were essential for this painting, which includes greens across the full spectrum, from pale lemon yellow through to deep ultramarine. The brushwork and colour combinations help to recapture the shimmering dappled light of that perfect afternoon on a delightful Provençal riverbank.

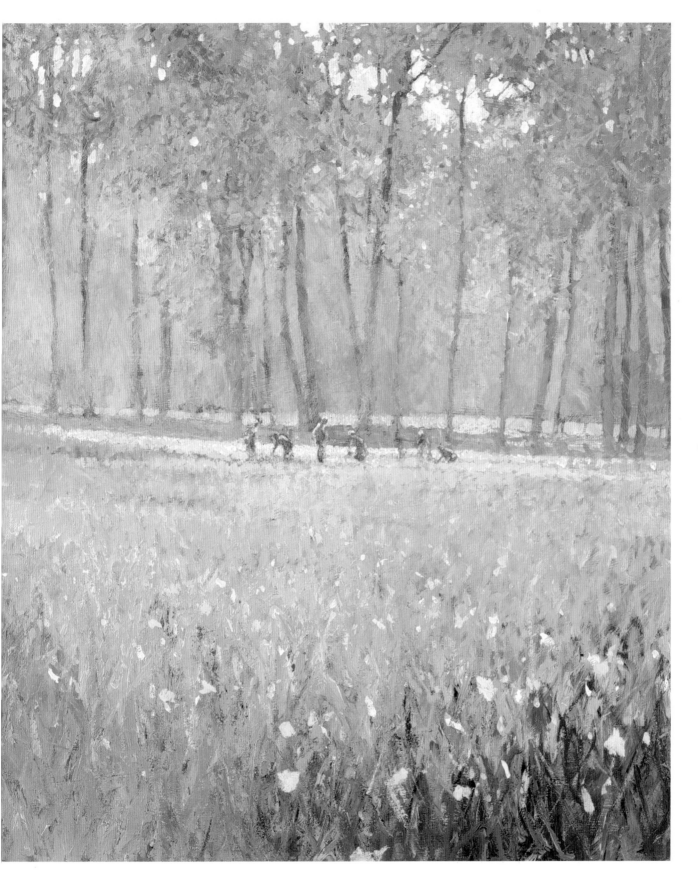

Essential Techniques

As in all media it is worth exploring a range of techniques, for this knowledge and experience will enable you to choose the most suitable method for any subject matter that interests you and the particular effects you require. The different techniques described on the following pages are the ones that I normally use, and I often combine a number of these within the same painting in order to convey the mood and impact I have in mind. But a great advantage of acrylic, of course, is its versatility and adaptability, which means that you are always free to experiment and modify techniques to fit your way of working.

34

Underpainting

Some artists like to apply their colours directly onto the white primed canvas or board and begin defining the shapes and modelling the forms straight away. However, I normally start by making a loose, monochrome underpainting, and then gradually developing the picture over that. For me, the advantages of the underpainting are that it blocks out the white ground, enabling me to establish a set of tonal values for the painting, and it creates a more receptive surface to work on. In contrast to a primed surface, which is slightly porous and consequently absorbs some of the moisture content of the paint, I find that working on an underpainted surface allows me to handle the paint in a much freer and more sensitive way.

I use a mixture of acrylic paint and gloss glazing medium for the underpainting, applying the paint quickly and freely with a large soft brush. The addition of the gloss medium gives the paint a high degree of translucency; this means that any initial pencil lines I have made to indicate the main elements of the composition will still show through. Nevertheless I don't mind if some of the pencil lines are lost – in fact it can be an advantage. One of the reasons I use this particular method of underpainting is that it creates an element of lost and found in the drawing. If the lines come and go it encourages you to reconsider the drawing when you start painting, rather than just filling in predetermined shapes.

TUSCANY - APR. 2000

Wash Techniques

In acrylic painting, my definition of a 'wash' is acrylic paint that is mixed with a generous amount of water to make a weak, free-flowing colour that can be applied rather like watercolour. Washes can be superimposed to build up richer colours and semi-translucent effects, or they can be used in pen or pencil line drawings to tint areas and give a colour reference. As I have mentioned before, care must be taken not to dilute the colour too much, because this also weakens the binder.

Barga, Tuscany, line and wash tonal study,
pen and acrylic on 300 gsm Langton watercolour paper
Late on a Tuscan summer's day I took the opportunity to make this quick study in which, by concentrating on tone rather than colour, I was able to explore the effect of directional light on the subject matter. Form is described by the variation in light as it plays on the different shapes and angles of the buildings, so giving three-dimensional structure to the image.

Wash techniques work best on watercolour or acrylic paper (see page 22) and they are ideal for quick location studies in which you want to record some aspect of the subject for further reference. I often make monochrome studies in this way to help me understand the quality of light in a subject. My study of *Barga, Tuscany* (page 35), is an example of this technique, while *Landscape, Tuscany* (above) and *Venice, location study* (opposite) demonstrate the line and wash approach.

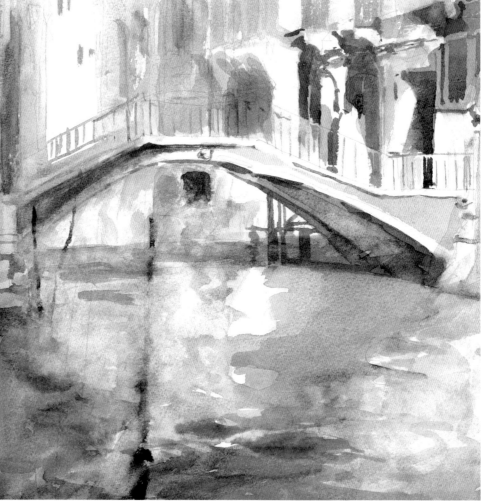

ABOVE: **Venice, location study**,
pencil and acrylic on watercolour paper
*I love to paint in Venice, whether it is a large painting for
an exhibition or a simple study like this for future use.*

LEFT: **Landscape, Tuscany, line and wash colour study,**
pen and acrylic on 300 gsm Langton watercolour paper
*This typical field study contains information on colour,
composition and tone and it will always be useful as a
reminder of my first-hand experience of the subject.*

Wet-in-Wet

When working on paper you can apply fluid washes of colour with a wet-in-wet technique, adopting a similar approach to that used in watercolour painting. Either wet the paper and paint directly into this area to create a blurred colour effect, perhaps for a sky, or run one wet wash against another so that they bleed into each other. But whichever method you use you must work quickly because, unlike watercolour pigment, once acrylic paint has dried it is no longer water-soluble. Adding fluid gloss glazing medium or acrylic flow improver will help increase the fluidity of the paint for wet-in-wet techniques.

I seldom choose these methods for works on paper, but for my studio paintings I often use wet-in-wet brushstrokes made with undiluted paint and applied to an area before the previous marks have dried. This creates a more random, broken and interesting passage of colour. Once again it is a technique that relies on speed, so I have a number of colours ready mixed and I use a selection of brushes, one for each colour. There is an extensive use of this technique in *Silver Light Waders*.

Colour and texture study on mountboard,
21.5 x 20.5 cm (8¹/₂ x 8 in)
I like to use scrap mountboard squares for on-site studies. Although they are light and easy to carry they are substantial enough to let me build up texture and layers of colour in a way that is close to the technique I used for finished paintings back in the studio.

39

Silver Light Waders,
65 x 60 cm (25¹/₂ x 23¹/₂)
Working quickly on a cold winter's day I wanted to capture the effect of the brilliant reflected light that dazzled for a few moments and then was gone.

Blending

This is the technique I use when I want to suggest a gradation in tone from light to dark, or make a subtle change from one colour to another. For example, in *From the Piazzetta, Venice* (below) the sky is very light on the horizon but the strength of the colour gradually increases until it becomes an intense blue at the top of the painting.

To create this effect, each brushstroke is overlapped slightly onto the previous one and pulled away towards the leading edge, thus blending the colour as it goes. I prefer to add slightly stronger (or weaker) pigment to my brush each time and do all the colour mixing on the picture surface, but equally it is possible to pre-mix the gradations of colour and work from these. Keep the brushstrokes as large and as spontaneous as you can. The paint must be applied wet-in-wet, but this should not be a problem if, like me, you use paint that is of a fairly thick consistency and you do not tackle too big an area at once. Alternatively, you could extend the paint's drying time by adding some retarder to your paint.

From the Piazzetta, Venice,
80 x 80 cm (31¹/₂ x 31¹/₂ in)
There are certain sights in Venice that are rarely free of people. If they are not in your subject, then they will be watching you paint it.

40

**Blue Shutters, Caught
in Sunlight,**
82 x 60 cm (32¹/₂ x 23¹/₂ in)
*As I crossed a small
backwater canal in a
residential area of Venice
the open shutters of a
waterside palazzo were lit
up by a shaft of sunlight. It
was one of those moments
that makes me glad to be a
painter! Here I have used
glazes to enhance the
impasto areas, where the
sun catches the building,
and also, applied them in
many layers, to give depth
to the dark shadows.*

Glazing

A glaze is a thin film of transparent paint.
Glazes can be superimposed, one over
another, to create areas of colour that have
depth and interest, or they can be used in
specific parts of a painting to enhance or
subdue other colours. They will work just as
well over an impasto area as they will over
thinly applied paint, and they can be used at
any stage in a painting. See *Blue Shutters,
Caught in Sunlight* (above).

Glazes can be made from paint thinned with
water, although I prefer to dilute the colours
with gloss glazing medium, which I think
gives better adherence, translucency, and
handling possibilities. If I need to make the
colour lighter I add more gloss glazing
medium. I never use white to lighten glazes,
because it makes the colour opaque.

42

Dry-Brush

Dry-brush is a means of creating a broken colour effect by allowing some of the previously painted surface to show through the new colour, so adding interest to an area or suggesting texture. It is a technique I like to use for foreground grasses, foliage and similar details and textures, as demonstrated in *Lavender Vista, Valensole*. It is also useful for highlights, such as glints of sunlight on water. Use a stiff-haired brush for this technique and just a little paint. I normally choose a hog hair brush, dipping it in the paint and then wiping most of the colour off. Then I lightly drag the brush across the appropriate area of the painting, letting it catch the surface here and there to create the broken colour effect. The particular quality of dry-brush work will depend on the painting surface (whether it is smooth or textured) and the consistency and amount of paint being used. If my tube colours seem too moist for this technique I will squeeze them out onto a sheet of paper first, to absorb some of the moisture.

Scumbling

This is similar to the dry-brush technique, and again it is a good method for achieving a broken colour effect. Mix and pick up the paint on the brush as before, but this time use a light, scrubbing action to apply the colour. Choose an old hog-hair brush and work with fairly thick paint. I often use a scumbling technique to give depth and texture to areas of shadow, perhaps adding a glaze across the scumbled area to unify it.

43

Lavender Vista, Valensole, 30 x 30 cm (12 x 12 in)
I have returned many times to paint the lavender fields of Valensole in Provence, southern France, and will, I am sure, never tire of them. The use of dry brushwork in the foreground helps create a greater feeling of depth.

Impasto and Texture

There are various gels and mediums that can be added to acrylic colours to help create an obvious textural surface to the painting, including some that contain particles of sand, black flint and other interesting materials. You can also make different textures by applying paint with a painting knife, sponge, rag and so on, or by using techniques such as stippling, spraying and dry-brush. And, of course, paint can be built up, layer on layer, to any thickness you like. Applying thick paint to create a textural surface is a technique known as impasto.

Not all of these techniques are appropriate for my paintings. Nevertheless, impasto work is an important aspect of my painting style, particularly for the light parts of a subject, as in *Curving Wave* (opposite). The slightly undulating surface of an impasto area causes the light to bounce off in different directions and this actually intensifies the feeling of light, especially sparkling light. In contrast, light areas look less scintillating on a flat surface. I also use impasto for paintings where I want to suggest shimmering light, such as sunlight breaking through the foliage of trees.

Varnishing

Whether or not finished paintings are varnished is a matter of personal choice. Acrylic varnish is flexible and non-yellowing, and its use will help protect a painting, unify the picture surface, and give depth to areas that have dried slightly 'chalky'. Most paint manufacturers produce a range of varnishes and therefore, to ensure compatibility, it is best to keep to the same brand as your paints. Varnish can be matt, semi-matt or gloss and either permanent or removable.

I varnish my paintings to protect the surface, and this is particularly important in works that are to be exhibited and sold. Additionally, because my painting technique often involves combining areas of gloss glaze alongside areas of matt-drying undiluted paint, the resultant picture surface can look rather irregular. I find that a coat of varnish will resolve this. I apply a single coat of matt varnish, using a large, soft brush and working quickly yet methodically across the surface. I am careful not to overwork areas as the varnish begins to dry, because this can cause cloudiness.

Curving Wave,
80 x 90 cm (31¹/₂ x 35¹/₂ in)
As here, thickly applied paint can be a very effective way of interpreting the light parts of a subject. In an impasto area the light will reflect in different directions, so intensifying the overall sensation of light.

44

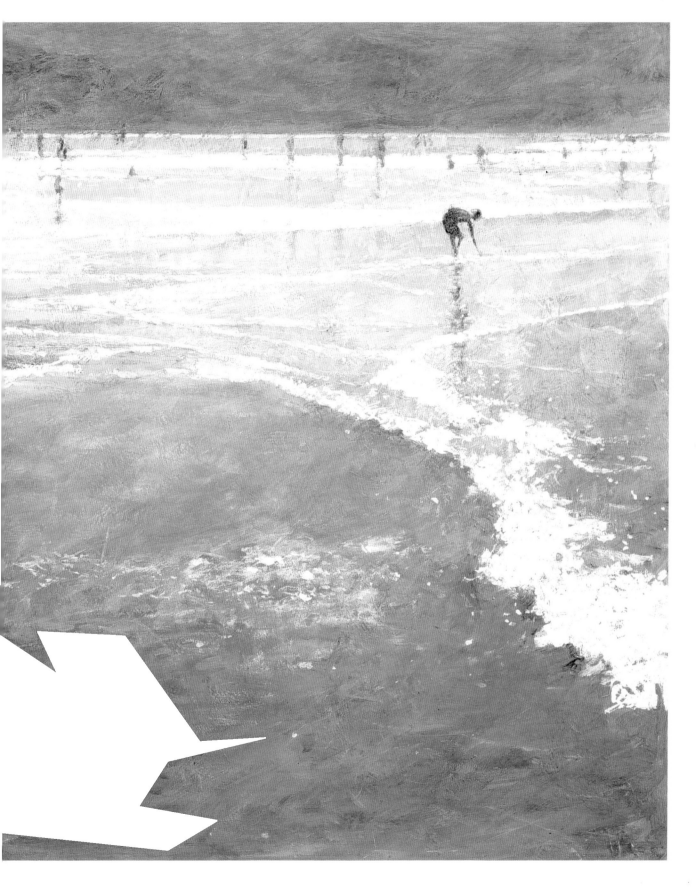

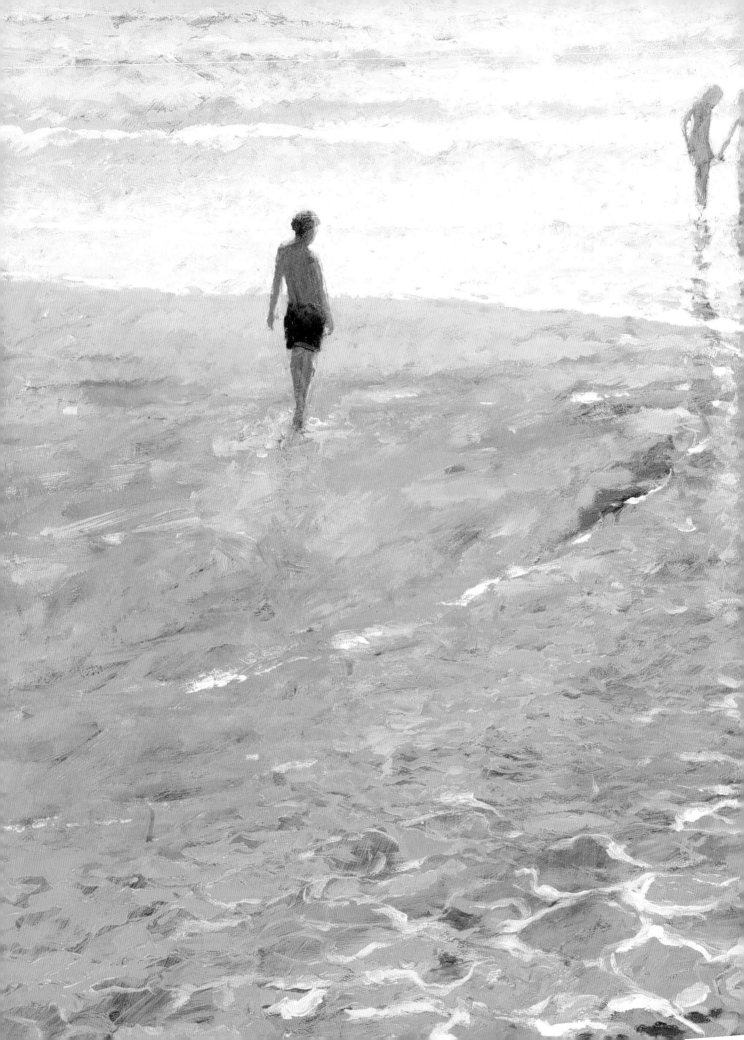

2 INTERPRETING LIGHT

Light is an important feature in everything I paint. More often than not it is a particular quality of light that initially attracts me to a subject and subsequently, as I develop the painting and aim to capture the scene at that specific moment in time, my main concern is with interpreting the effect of light. It is light that gives a subject its distinctive mood and impact and, for me – whether I am painting buildings in Venice, landscapes in Provence or winter coastal scenes in south Devon – light is always the unifying element.

The difficulty in trying to depict any type of light is that it has a transient quality. Even on a calm, cloudless day the intensity of light will gradually change as the sun moves across the sky, altering the shadows and influencing the character and atmosphere of the scene. Therefore the time available to assess and paint a particular effect can be very limited. There may be an hour or two of fairly consistent light, but equally, things could change the next minute. Because of these constraints it is seldom possible to make resolved paintings on site. So I explore other ways of recording and holding onto that moment in time – ways that help me work just as effectively and with just as strong an emotional involvement when I am back in the studio.

In my paintings I want the viewer to feel as though they are there, standing in front of the subject, because I believe that conveying a feeling, a sense of place, is just as important as making a visual record. Therefore, on location, as well as making sketches – perhaps both in pencil (tonal) and in colour – and maybe taking one or two photographs for general reference, I often make some written

The Warm Shallows,
72 x 60 cm (28¹/₂ x 23¹/₂ in)

47

notes. I jot down information about the light and other qualities about the subject that are distinctive and important, including any sights, sounds and smells that will help jog my memory and enable me to 'relive' the scene when I come to paint it. Observing, recording and memorizing all play a vital part in my location work.

To express in paint the feeling of, for instance, a misty, diffused light, a dappled light, or any other light effect, depends just as much on distilling information from the subject and deciding what to include and what to leave out, as it does on painting technique. There are no set techniques for painting light. Obviously when you are selecting colours,

paint consistency and painting techniques you must be sensitive to the quality of light that you want to create. These decisions are based on observation rather than set formulae. It doesn't follow that hazy conditions should always be suggested with glazes, for example, or that a stormy, turbulent atmosphere is best implied by using heavy-bodied paint. You have to be receptive to what is going on around you. If you are willing to be subjective – and so focus on those things that contribute to the mood of the scene – rather than trying to include everything, then your painting is more likely to be successful.

HE'S JUST PUT THE UMBRELLA OUT. - BUDLEIGH.

Light and Tone

The tonal range within any subject will depend on the light conditions prevalent at the time, and consequently it is an important element in capturing the essence of that moment. As well as setting the mood, defining form, helping to describe the physical nature of the subject and conveying spatial depth, the tonal range chosen for a particular painting will give information about the time of day, the weather conditions and the effect of light.

Everything we see has a tonal value and this is normally described as being dark, grey, light and so on. Consequently, tone is a relative property: it is only when compared with dark that light is defined. So, for example, a light object appears lighter when it is seen against a darker background, and vice versa. In observing, understanding and communicating the properties of light it is essential to consider this relationship. By so doing, and in developing an understanding of the significance of tonal values generally, you will be able to work with a greater awareness of light and be better equipped to convey its strong influence and varying effects in your paintings.

Beach Huts, sketchbook study,
pen and wash
This tonal sketch was drawn quickly early one morning when there was the threat of rain. I knew I was going to get wet when I saw the man from the kiosk putting out his umbrella!

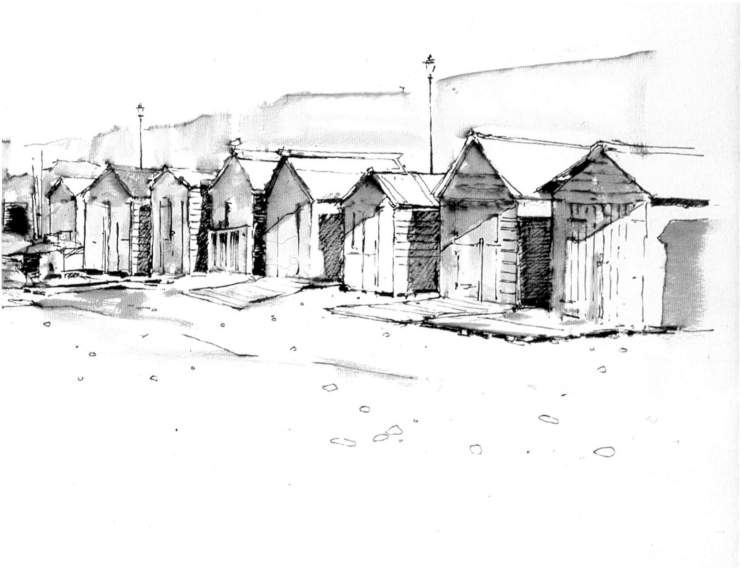

Understanding Tone

It follows that to convey a particular quality of light you must be able to assess and interpret the tonal range in a subject. Estimating tone, rather than seeing something purely in terms of colour, can be quite difficult. But, like most things to do with painting, with practice and experience it soon becomes second nature. For example, in time, as well as looking at a field and seeing it as green, you will also see it as a distinct tone – or perhaps several tones – of green, relative to its surroundings.

A technique that many artists use to help them judge the variations of tone in a subject is to look at it through half-closed eyes. This not only gives a better perception of tone rather than colour, but also a more useful, simplified view of the tonal range, with the contrasts of light and dark more obvious. Something else which can help in understanding tone and its importance in a painting is to photocopy or photograph some of your work in black and white. By thus eliminating colour and reducing the picture only to a range of tones you can check to see if you are using tone effectively. It may be that you need to work with greater contrasts of tone to give more interest and impact to your paintings.

In my location studies tone is the first thing I consider in terms of trying to understand what is happening with the light. Sometimes, as in *Boats at Totnes* (below), I deliberately start with a tonal drawing, but usually the analysis of tone is incorporated into the general reference drawings that I make in pencil or pen and ink. Later, in the studio, the way I use these drawings will depend on the individual subject matter. Having made a mid-tone underpainting, which gives me a reference from which to work towards the extreme lights and darks, normally my starting point is an area that particularly excites me or where the light is playing its most important role – very often in the sky or the water.

Boats at Totnes,
25 x 24 cm (10 x 9¹/₂ in),
pencil
At low tide the flow of water in this river bed in south Devon drops to a trickle. The sunlight reflects back from the wet mud and the surfaces of the boats in brilliant contrast to the dark tones of shadow and shoreline. I did this pencil drawing to explore these tonal extremes for a series of paintings that I had in mind (see opposite).

50

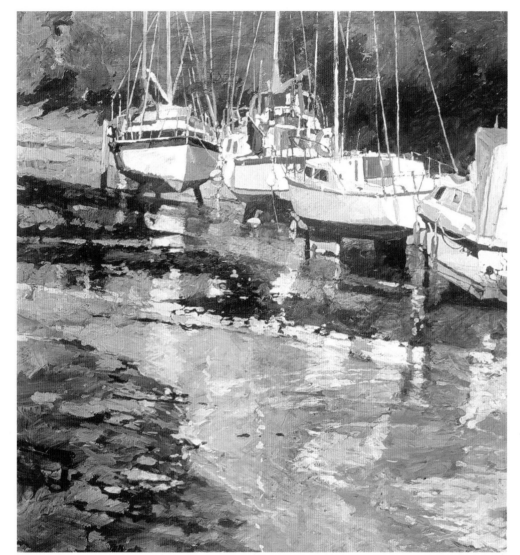

**Sunlit River Bed,
Totnes,**
90 x 80 cm (35¹/₂ x 31¹/₂ in)
*The abstract pattern of the
broken reflections of these
boats on the mud and
water fascinated me and
became a significant
element in this painting.*

51

Tone and Colour

Despite the value of thinking about and experimenting with tone on its own, ultimately, tone and colour cannot be separated. In assessing the tone we are considering the relative light/dark value of the colours. Tone relates to colour in two ways: firstly, each colour has an inherent tone, so that yellow, for instance, is a naturally light-toned colour and purple a dark one; secondly, and irrespective of this, within each colour there can be many variations of tone, according to how much it is diluted or which other colours it is mixed with.

Mixing a colour of the right tone is never just a matter of adding white or black. In fact this will usually create a quite different colour. I use two methods to adjust the tone of a colour. For areas that have already been painted but where I then decide that the tonal value needs strengthening or weakening, I often apply a glaze or succession of glazes. Alternatively, during the painting process, I will alter the tone of a colour by adding some paint which is a lighter or darker version of that particular colour.

As an example, when I am painting foliage, I might mix a selection of greens on my palette and then, if I want different tonal variations, I mix them from this initial range, being careful always to preserve some of the original colour. However, at the same time as considering the tone of the green, I am also thinking about its other qualities. For instance, as well as needing to adjust the tone I may also have to alter the hue (colour) by adding a little bit more yellow or red.

Tone and Form

Just as an understanding of tone is essential for interpreting the quality of light, equally it will enable you to use tonal variations to suggest solidity and create three-dimensional form. Every object is defined to some extent by the light falling on it. So, noticing the source and direction of light and how it plays across different surfaces should be an important part of the initial observation and recording process. In turn, this information has to be translated in the painting process. For example, on a curved surface such as the dome in *Santa Maria della Salute, Venice* (below), there will probably be a tonal variation from highlight to shadow.

Similarly, changes of tone can suggest depth and space. Theory suggests that objects in the foreground are bolder in tone and those in the distance look subdued and less defined. This is worth bearing in mind, but I often find that in practice distant trees and other objects can appear quite dark in tone. The way I create depth is by giving elements in the foreground much stronger tonal contrast, keeping the distant shapes, whether dark or light, to a more restricted tonal range.

I also like to exploit tonal values to help me convey the mood of the painting. Subtle tones can express a calm feeling, for example, while obvious tonal contrasts, by creating a more active picture surface, can give an air of excitement.

Santa Maria della Salute, Venice,
80 x 90 cm (31¹/₂ x 35¹/₂ in)
This view presents a new and exciting challenge each time I paint it, as the light and atmosphere of Venice constantly changes.

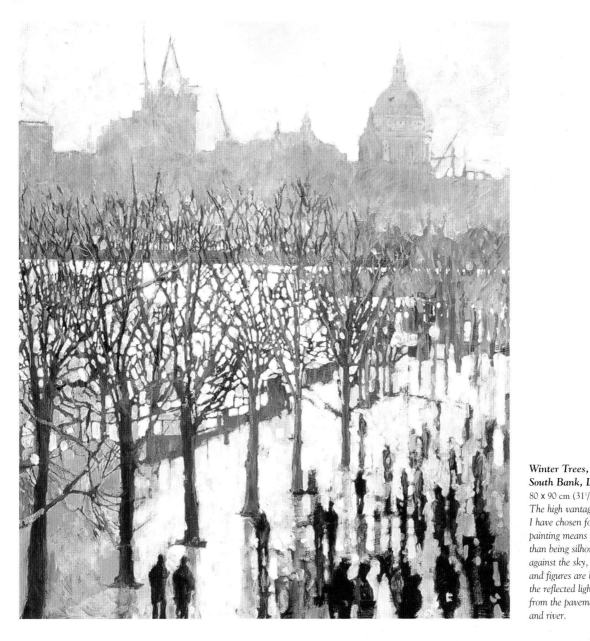

**Winter Trees,
South Bank, London**
80 x 90 cm (31¹/₂ x 35¹/₂ in)
*The high vantage point
I have chosen for this
painting means that rather
than being silhouetted
against the sky, the trees
and figures are backlit by
the reflected light coming
from the pavement
and river.*

Tonal Counterchange

The same principle applies to subjects where there is what I would describe as a lot of 'visual noise', such as a crowd scene. Here I may introduce small areas of strong tonal contrast to give movement, interest and depth. Often this method will include the use of tonal counterchange (placing light shapes against dark ones, and vice versa), which is another device that is useful in your painting 'armoury' to call upon when appropriate for the subject. Sometimes a section of the painting treated in this way makes a striking focal point, as in the figures in *Morning Sun, San Marco* (page 54).

Light and Colour

Colour, with its inherent tonal values, is one of the basic and most important attributes of a subject. Consequently, in deciding how to convey the effects of light and mood one must observe and understand what is happening in terms of colour. It is the choice of colours, combined with the techniques used to express these colours, that are significant factors in capturing a particular quality of light. In practice there are two aspects of colour to consider: its descriptive power in the subject matter, and its physical appearance within your painting.

Descriptive colour is concerned with the local colour (the actual colours within the subject) and the tonal variations that help convey shape and form, although artists are obviously free to interpret these colours subjectively as well as literally. The physical appearance of colour relates to the feel and texture of the

54

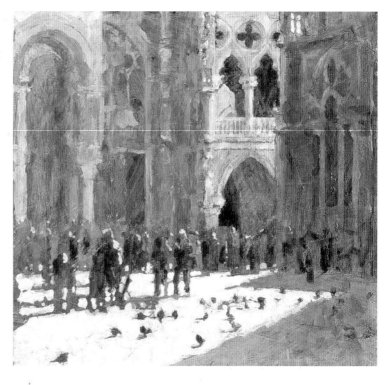

**Morning Sun,
San Marco,**
30 x 30 cm (12 x 12 in)
*I have used strong tonal
contrasts and a limited
colour range to capture the
morning sun as it starts to
break through the gaps in
the buildings and the
Square of St Mark's in
Venice takes on a
theatrical air. These
moments are fleeting
but stay in the
memory forever.*

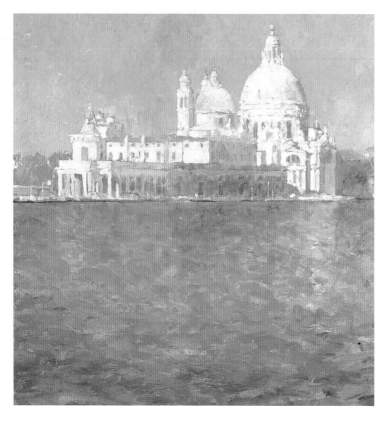

Sunlit Lagoon,
40 x 40 cm (15¹/₂ x 15¹/₂ in)
*Strong directional light
defines the form of this
distant view, allowing me
to describe the structure of
the building in simple,
confident brushstrokes.*

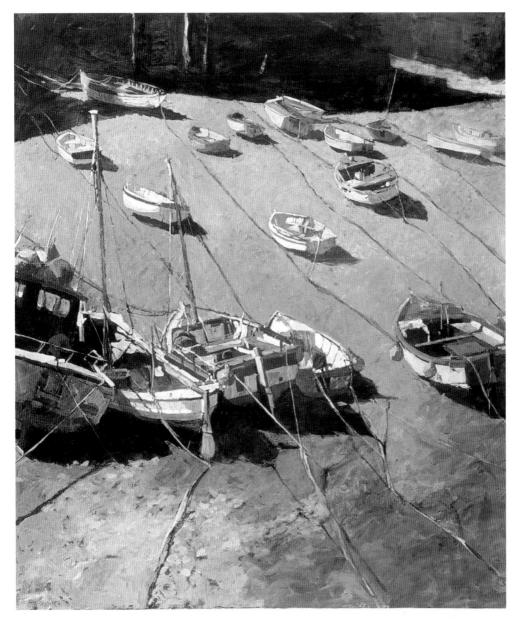

55

Golden Harbour,
90 x 80 cm (35¹/₂ x 31¹/₂ in)
*The seemingly random
way in which the falling
tide places these fishing
boats on the harbour bed
gives rhythm and pattern
to a strong composition.*

paint – the way it is applied to the board or canvas. Again, this can help describe the subject, but equally it influences the mood of the painting, and it can be especially significant in helping to achieve different lighting effects.

Initially, as well as judging the light and dark contrasts in a subject, I also look for the colour relationships that are distinctive to the scene and which will help me express it in the way I want. The light and colour values are always specific to a particular time and light source, and this is something that will be influential in the painting, even if the light source is outside the picture area. In a landscape scene at sunset, for example, many areas will be bathed in an orange-pink light. I often build up such effects by overlaying glazes of colour, as these allow more control, but appropriate colour adjustments also have to be made in the development of the painting and when mixing the colours to be applied.

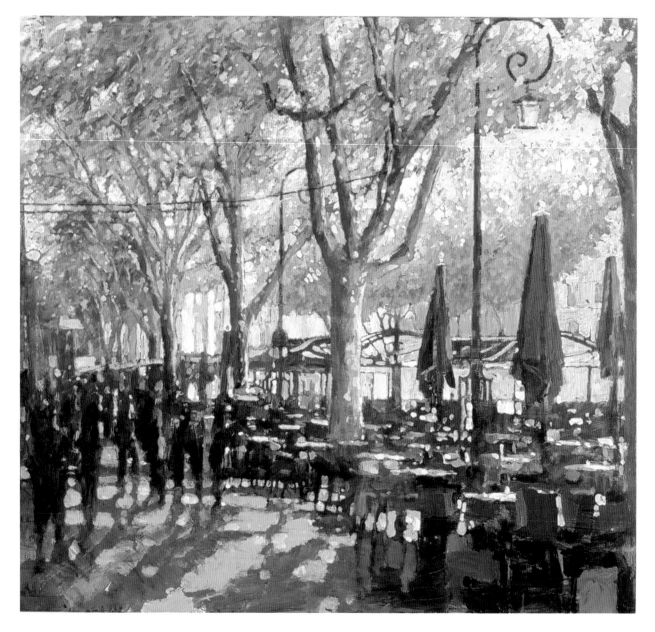

56

Harmony and Contrast

In most subjects the colours show a combination of harmony and contrast, and indeed this contributes to their interest. Usually the impact of the colour, and therefore most likely the drama of the light, is far more effective if there are quieter, subtle passages to complement areas that have strong, vibrant colour. A concentrated mass of one kind of colour tends to dominate or, paradoxically, it can seem rather dull.

Generally, interpreting the play of light and shade relies on exploring harmony and counterpoint in the use of colour.

As with tone, the more you increase the colour contrast, the more active the picture surface, and this is something you can exploit in expressing your emotional response to the subject. Through the choice of colours, and their arrangement within the painting, you

Place de l'Horlogue, Avignon,
80 x 90 cm (31¹/₂ x 35¹/₂ in)
The marvellous plane trees casting their dappled shade dominate this setting in southern France. The red of the café parasols contrasting with the green of the foliage above them is an irresistible combination.

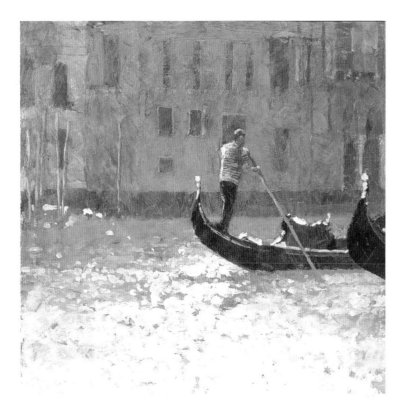

Grand Canal,
Light and Shade,
30 x 30 cm (12 x 12 in)
I am constantly drawn
to the subject of light
reflecting off water.

can influence the mood of the work and how people react to it. However, this isn't to say that every painting must involve extremes in colour temperature (warm/cool colours) or colour intensities. The degree to which you develop the counterpoint will depend on the subject and the message you want to convey. Sometimes you may want to suggest a more tranquil scene and explore harmony and variety using quite a limited palette, such as a range of blues and greys in a seascape.

I like to use harmonies and contrasts in this way, so that the colour conveys a real sense of atmosphere and a particular kind of light. For example, if I want to suggest a vibrant, shimmering light, similar to that shown in *Place de l'Horlogue, Avignon* (opposite), I will use small marks of contrasting colours interspersed across an area. In this particular painting, red and green – which are colours that react quite strongly with one another and thus set up a visual vibration – have been used to enhance the light effect. It is also worth

remembering that every colour has certain qualities and associations that influence its emotional impact. We think of 'sky blue', for instance, or 'blood red'. Blue is generally considered a cool, calming colour and red, a hot, fierce colour. As always of course, these are conventions to be considered rather than hard-and-fast rules to follow.

White Farm, Volterra,
40 x 40 cm (15¹/₂ x 15¹/₂ in)
Another of my favourite
subjects. These old farm
buildings that are scattered
throughout Tuscany give a
perfect focal point to small
landscape studies.

Expressive Colour

As I have said, observation is the starting point for decisions about colour. However, I have also stressed that the intention in my paintings is to express a personal response to the subject rather than simply copy what is seen. Naturally, to reflect my feelings I am selective, and this applies as much to colour as any other aspect of the subject. I concentrate on those colours that seem to quantify and characterize the subject, often emphasizing these rather than other areas of colour, which may be altered, simplified or disregarded.

Colour is the key element in helping you communicate what it is you wish to say about the subject. Even if you prefer to work in a naturalistic way you will probably need to enhance the colour contrasts to some extent beyond what you see in the subject, in order to give the painting a more dynamic and exciting quality. You could also decide to depart from the actual, observed colour scheme altogether and work purely subjectively. But whatever the approach, it is the relationships and interactions between the colours in your picture that matter. All the time you are painting you have to be aware of the combinations of colours you are using in your painting and the overall feeling these are creating.

In fact, whatever your aim, simplification and subjectivity must always play a part in your painting, because when translating a three-dimensional scene into a two-dimensional representation it just isn't possible to recreate a subject in every detail. Moreover, like everyone else, you will instinctively edit what you see. Some things will impress you while others seem less important – however hard you look and try to understand, you cannot take in every nuance and detail, so when you

select the features that you want to emphasize in your painting, you are making an individual judgement, even if it is sometimes an unconscious one. This is, I believe, exactly what we should be painting – an individual response, rather than attempting a photographic copy.

Interestingly, if I take some photographs on location for reference (in addition to making sketches), invariably when I come to look at the results in the studio I find that they fail to capture my feelings about the subject as I remember them. Of course the photographs do not lie, but what they do show is that, unlike me, they cannot be selective or emotional about the subject. They help to jog my memory, but I don't rely on them for anything more than that!

Harvest of the Sun, Tuscany,
40 x 40 cm (15¹/₂ x 15¹/₂ in)
High contrast and strong colour give heat to this painting, which glows in the same way as the Tuscan landscape itself, towards the end of a long hot day.

58

Where Watchers Walk, Topsham,
80 x 90 cm (31¹/₂ x 35¹/₂ in)
On a bitterly cold winter's morning, at a spot much favoured by bird watchers, I had decided it was too gloomy for painting. But when the sun broke through for a moment and a pool of light flashed across the estuary of the river Exe in south Devon I saw that what I had believed to be a very grey subject was, if predominantly monochrome, nevertheless full of subtle colour variations.

Limited Palette

If you compare some of the paintings in this book you will see relationships in the colours I have used; you will also notice differences. I keep to a limited palette of colours in most of my paintings and although I always work from the same basic range (see page 18), the way these colours are used is specific to each subject. I rarely use colour directly from the tube, preferring to mix the colours I require.

My intention in every painting is to develop a range of colours that suit the light and mood I want to convey – see, for instance, *Where Watchers Walk, Topsham* (above). The way I achieve this is by being aware of the defining features of the subject and its particular light effects. Then, perhaps with comparison to

similar subjects I have painted before, I mix the colours that I think will characterize that specific time and place. Obviously each geographical region requires a slightly different palette. But even when painting several pictures in the same place – in the lavender fields of Provence, for example – there are subtle differences in the colour mixes required for each painting.

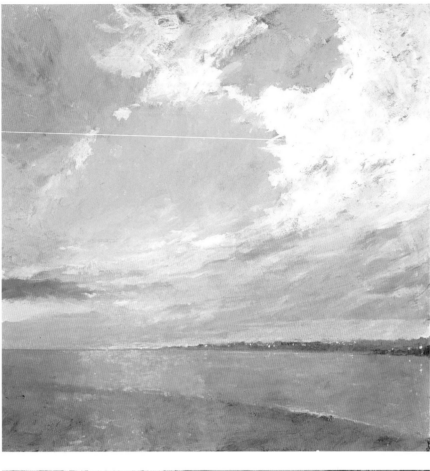

**Sweeping Bay,
Towards Exmouth,**
60 x 60 cm (23¹/₂ x 23¹/₂ in)
*In this coastal study in
south Devon I wanted to
capture the wonderful
feeling of movement in the
sky against the stillness of
the water. I used a limited
palette of colours to
enhance the feeling
of calm.*

60

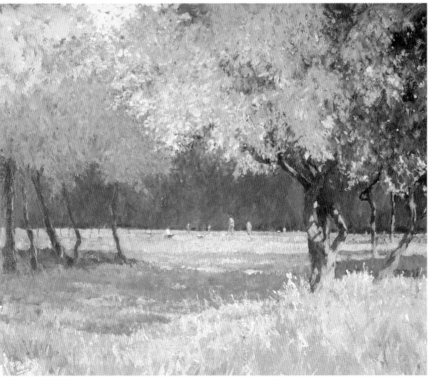

**Day's End Orchard
Clearing,**
50 x 60 cm (20 x 23¹/₂ in)
*I love to draw and paint in
orchards. The combination
of natural and cultivated
landscape, with wild
flowers and grasses
alongside pruned and
tended trees, perhaps filled
with people at work or
simply resting, always
guarantees exciting and
stimulating subject matter,
particularly in the
evening light.*

Shadows

Shadows are the most obvious manifestation of the effect of light, and so they play a significant role in creating a feeling of light and atmosphere in a painting. Moreover, they help to define forms and qualify surfaces, and they can be an interesting and important compositional device. Shadows are areas that can contribute a great deal to the overall impact and success of a painting.

Light and Shadows

The characteristics of different shadows – their size, shape, angle, tone and colour – are influenced by the strength and direction of the light source. Usually the source is outside the picture area, but it is worth noting where it is, and consequently the direction of light, so that you can ensure a consistency in the direction and nature of the shadows throughout the painting. This is something that may be overlooked when painting on location as the light is gradually changing. Here, once more, observation is important. It is very easy to have preconceptions about shadows, but rather than making assumptions, the best approach is to treat them as you would any other part of the subject and therefore begin by assessing their individual qualities and how these can be used effectively in the painting.

I do not apply the shadows at a particular stage in the painting. In my work the shadows are areas that evolve throughout the painting process and I will constantly adjust their tones and colours so that they relate to the lighter areas and everything else that is going on in the painting. Often, in the final stages of a painting, I may decide that certain shadows need strengthening or reducing, making warmer or cooler, and so on.

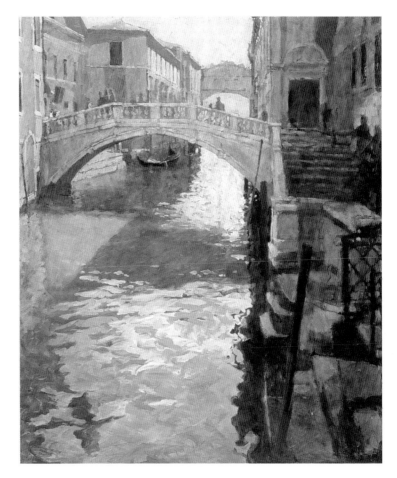

Rio del Palazzo,
90 x 80 cm (35¹/₂ x 31¹/₂ in)
The attraction of this Venetian subject was not only the contrast between shade and sunlight on the different sides of the canal, but also the challenge of painting the shadow falling on the surface of the water. Notice the difference in temperature between the reflected light of the sky in the shadows and the warm patch of sunlight on the far side of the canal itself.

61

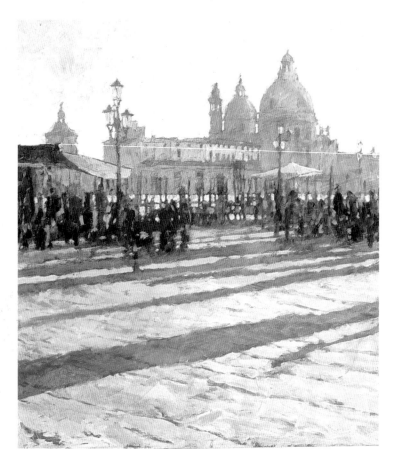

**Long Shadows,
Molo San Marco,**
40 x 40 cm (15¹/₂ x 15¹/₂ in)
*Of course the later in the
day it gets, the longer and
more dramatic the shadows
become. However, the
disadvantage of this is
that they also change
considerably faster, so,
whether drawing or
painting, it is important to
record information quickly
at the outset.*

Shadows and Composition

As well as being a means of depicting a certain kind of light, the shadows in many of my paintings also contribute in a very positive way to the dynamism and impact of the composition. In fact, in some paintings the shadows are the dominant feature, as in *Long Shadows, Molo San Marco* (above).

Foreground shadows are particularly useful in this respect. They can help define and describe areas that are lacking in specific features and, as far as the composition is concerned, they lead the eye into the painting, directing our attention towards the main area of interest. The strong, diagonal foreground shadow in *Purple Shade, St Mark's* (opposite) perfectly demonstrates this point. In some paintings I like to include a dappled or broken foreground shadow, as this conveys atmosphere and has the added advantage, in a café scene, for example, of creating a sense of movement.

The direction, shape and changing tone of shadows can help suggest depth, while another interesting possibility is to include a shadow that appears to originate from behind the viewer and so directly involves them within the picture space. Shadows of this type are not always actually there but, if necessary, can be introduced or 'borrowed' from other parts of the subject or from objects nearby, perhaps from a tall tree just outside the picture area, for example. I am careful to ensure that the angle of any introduced shadows fits in convincingly with the overall fall of light.

**Purple Shade,
St Mark's,**
60 x 50 cm (23¹/₂ x 20 in)
*It is impossible to paint
in St Mark's Square in
Venice, which is almost
totally enclosed on all
sides, without considering
shadows. From early in the
morning, when the sun
first breaks through, until
the end of the day, when
the last few rays catch the
façade of San Marco,
there is a constantly
changing atmosphere as
well as all kinds of
compositional possibilities
to tempt the artist.*

Painting Shadows

There are various theories concerning the colour of shadows, one of which claims that a shadow colour will always contain the complementary colour of the object that casts it (the colour that is opposite it on the colour wheel). Perhaps theories are worth keeping at the back of your mind, but there are so many things that can affect the colour of shadows that the only true assessment can come from close observation. Even then, the colour or colours seen must be judged in relation to how they will work in the painting, and they may need modifying.

Shadows are seldom simply grey or black. Their colour will be influenced by the surface on which they fall and it will reflect to some extent the surrounding colour. The method I use to judge shadow colours is the same one that I use for other elements in a painting – by comparing them to neighbouring colours. Cross-referencing in this way, I can assess the tone and type of colour mix I need. But I do not worry if the colour doesn't seem exactly right when I first paint it onto the board, because I know there will be a process of adjustment as the painting evolves. An advantage of the quick-drying nature of acrylic paint is that areas can easily be reworked.

Another point to note when painting shadows is that they are never just flat areas of colour. They contain variations of colour and tone, which is another reason to treat them exactly like any other area of the painting. Although there are a few occasions, for example, when I would paint part of a building and then superimpose the shadow colour by the use of glazes, generally I consider the shadow as an element in its own right. However, I might work the other way round, and apply patches of light over a shadow, for example, spots of light where the sun breaks through the shade of a tree canopy.

A Place to Pause,
57 x 60 cm (22¹/₂ x 23¹/₂ in)
The empty chair in the shade of the tree was so inviting, it almost called to passers-by to stop and rest. I wanted to convey that peaceful feeling in this painting. The use of smoother brushstrokes beneath the tree, contrasting with the more animated marks in the tree canopy above, give a feeling of calm to the seat and table.

64

Leafy Square, Aups
(stage 1)
A complex subject such as this requires a high level of drawing. On a primed board, drawing with quite a hard pencil, I start to compose the painting from the reference material gathered on site.

65

Leafy Square, Aups
(stage 2)
With a loose underpainting I begin to establish the tonal composition and create a surface on which I can develop the painting. In this case I am struck by the vibrancy of the areas of shadow in the subject matter and have chosen the colours for the underpainting accordingly.

Leafy Square, Aups
(stage 3)
Once the underpainting has dried I apply areas of more opaque colour. As the title suggests, the large plane tree in this French square influences its surroundings dramatically, and it is the obvious starting point. After painting the texture of the weathered trunk and dense canopy of leaves above, I begin to refine its form by adding the brilliant sunlit wall behind it.

66

Leafy Square, Aups
(stage 4)
With most of the darkest tonal accents in place I am able to assess continually the colour and intensity of areas of bright light. Working across the whole picture surface I apply contrasting areas of light and shade, building up shadows with glazes and scumbled colour to give them a glowing warmth, and laying patches of light over them with impasto strokes.

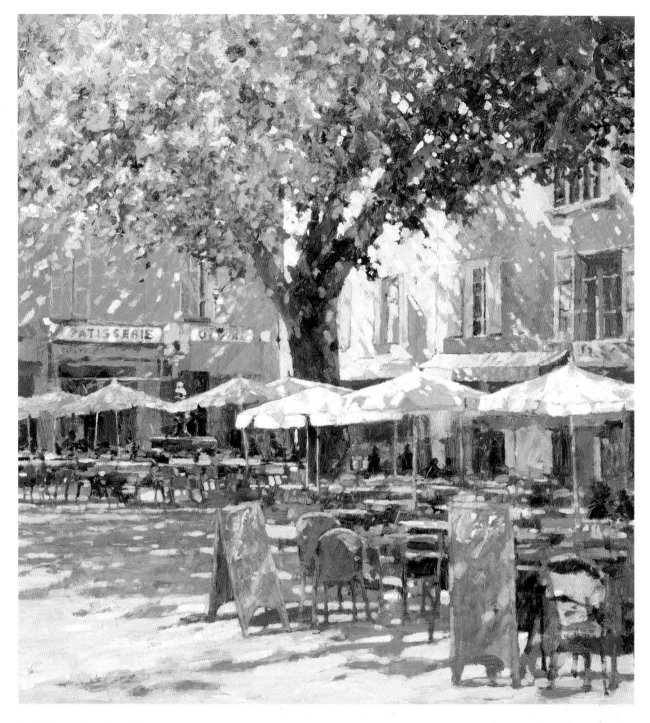

Leafy Square, Aups (stage 5)
The painting is now complete. I have suggested the exciting clutter of foreground tables and chairs using lively brushstrokes. Warm glazes have been laid in across areas of the tree and into the shadows, while bright accents of yellow, white and lavender give the painting a true feeling of dappled sunlight.

Changing Light

Invariably the light effect that first attracts me to a subject will be a transient one, so I have to work quickly to capture that quality of light before it changes and creates quite a different mood and atmosphere. There are occasions when I can paint for a significant period on the spot, for example on a bright, sunny day when the light looks settled for a time. But usually the light effect is a fleeting one and I have to use additional methods to record information. What is important for me is to note down those aspects of the scene that identify a specific moment.

Back in the studio I want the painting to reveal that moment rather than show a generalized, timeless representation. So, when I am on location, the thing I concentrate on first is the light. I make quick pen and ink sketches and written notes to remind me how the light looked and felt. Sometimes the sketches are quite basic, perhaps more like scribbles, but this type of 'shorthand' visual note can be sufficient to help me recall the place and mood. Once I have recorded whatever information I think I need about the light, I consider the features

68

Early Morning, Provence,
60 x 60 cm (23¹/₂ x 23¹/₂ in)
As the title suggests, this painting was begun early in the morning. One of the challenges of painting at the beginning or the end of the day is that the moment-by-moment variation in light is so dramatic and time is very limited. One way to deal with this problem, as here, is to begin painting on site, which allows you to record basic information quickly, make some colour notes and absorb the atmosphere. Then, as I did, you can complete the painting in the studio from your reference material and your own memories of the subject.

that are not transient: the undulations of the landscape, the buildings, trees and so on. I may decide to make a colour study on location, perhaps working with acrylic washes on paper, and in some cases I also take some photographs as well.

All of this material is useful in the studio, not as something to copy but as a source of reference. Additionally, although previous paintings may help inform judgements and, once underway, the painting itself will suggest a certain direction and approach, my memories and feelings for the subject are always the dominant factors.

Full Sun,
Valensole Plain,
30 x 30 cm (12 x 12 in)
In the middle of the day the movement of the sun seems to slow down and there is a period when the light quality is fairly consistent. The disadvantage of course is that temperatures can soar, not only affecting the properties of the paint but also testing the resolve of the artist!

Dusk Approaching, Valensole,
40 x 40 cm (15¹/₂ x 15¹/₂ in)
I do like to paint towards the end of the day. There seems to be a heightening of the senses, with colours and tones becoming richer, and of course in the lavender fields of Provence, impossible though it seems, the scent becomes even more intense as dusk approaches.

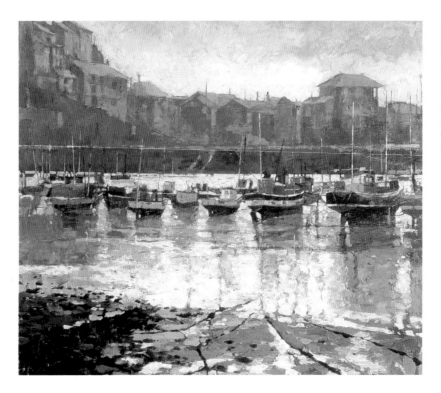

*Low Tide,
Mevagissey,*
80 x 90 cm (31¹/₂ x 35¹/₂ in)
*A low sun gave the
harbour at Mevagissey in
southern Cornwall a very
moody feeling. My
painting became a study
of extreme tonal range,
adding to the drama.*

Different Times of the Day

70

The quality and intensity of light changes
throughout the day and it is interesting to
paint subjects that reveal these differences, as
demonstrated by my three paintings of
lavender fields (pages 68 and 69). The
contrasting effects of light, from early
morning to dusk, create quite different
sensations of atmosphere and colour, offering
a fascinating challenge to any artist and
heightening their awareness and
understanding of different tonal values and
colour relationships.

I seldom deliberately return to a subject to
catch it at a particular time of the day. Instead
I paint and sketch subjects as and when they
inspire me, whatever time of day that happens
to be. However, as I have said, I appreciate
that it can be very rewarding to paint the
same subject in different light conditions, and
I know that many artists like to work in this
way. Monet was a notable example, of course.

While I have never specifically painted a
sequence of pictures of the same subject at
different times of day, I do sometimes explore
this idea through recurring themes. The
lavender fields are a case in point. They are
not at precisely the same place, but three
similar places. Over a period of time I do go
back to some locations and paint things that I
have painted before. I often return to the
church of Santa Maria della Salute, in Venice,
for example. What I like here is the fact that
the architecture is solid and unchanging but it
is surrounded by an ever-changing light and
atmosphere. The experience is never quite
the same twice and inevitably I choose a
slightly different viewpoint each time.

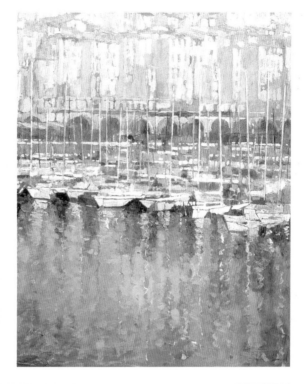

**The Marina,
Menton,**
90 x 80 cm (35¹/₂ x 31¹/₂ in)
*The light at Menton, on
the coast of Provence in
southern France, can be
very intense, but what
captured my attention
here was the contrast
between the brightness of
the water and the pale
golden light that fleetingly
bathed the buildings.*

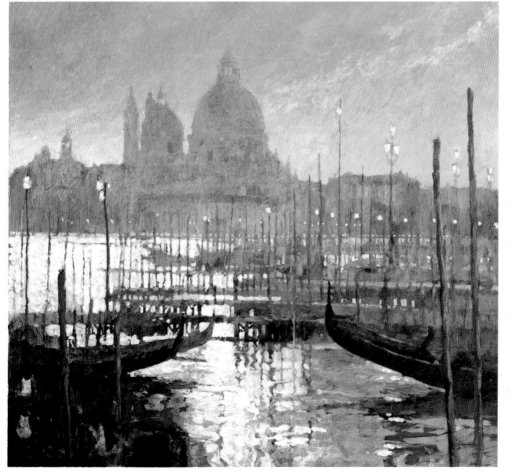

**Santa Maria della Salute,
Venice Lights,**
80 x 90 cm (31¹/₂ x 35¹/₂ in)
*This is one of my favourite
times of day in Venice. As
day gives way to night, the
distinctive pink glow of the
ornate lamp standards
becomes stronger and the
failing light on the horizon
throws Santa Maria into
silhouette. I used an inter-
layering technique of impasto
and glazes to give the subtle
variations needed to capture
these effects.*

Reflections on the Shore,
30 x 30 cm (12 x 12 in)
*Light, silhouettes,
reflections, shadows – I
think I'm in heaven!*

Contre-jour

Any artist who enjoys painting light will at some point turn their attention to subjects that are *contre-jour* (literally, 'against day'), so exploring contrasts of light at the most extreme level. In *contre-jour* the subject is seen against the light and consequently much of it is in silhouette or partial silhouette. Because the amount of overall colour that can be seen is drastically reduced, essentially the painting becomes a high-contrast tonal study. Sometimes this will be punctuated with stunning accents of bright colour, where for example a translucent object is illuminated by the light passing through it, contrasting dramatically with the bold, dark shapes of solid matter.

What particularly interests me about *contre-jour* is the way that bright light seems to dissipate the edges of some objects, creating exciting lost-and-found effects. Sometimes the light is so bright that it is really difficult to look at the subject for more than a few minutes at a time, but this is usually long enough to get a feeling for what is there and note it down accordingly. In some subjects it pays to exaggerate the tonal contrast in order to create the maximum impact, while in others a more subtle approach is just as effective, as in *Reflections on the Shore* (above).

Weather Conditions

Naturally the weather is a factor in the quality of light and it may also be a consideration in the choice of subjects and the approach and techniques to use. There are some days when it is simply too unpleasant to paint or sketch outside but, having said that, it is surprising just how much discomfort artists will endure when inspired by something. When I started painting *Morning Ice, Slimbridge* (below, right) for instance, on a freezing cold day it included one or two unintentional wavy lines where my hand was trembling!

Experiences like this are very memorable and in fact help tremendously later on when you are in the studio and want to recreate that same feeling in a painting. I could not envisage painting any subject which I had not personally seen and felt some kind of response to, and often the weather is an aspect that helps me recall those experiences.

Providing you set out prepared for the likely weather conditions, it is possible to work outside throughout the year. This means ensuring that you are reasonably comfortable (warm enough, cool enough and so on), are willing to try a different subject or approach if the conditions change, and accept that paint drying times and other factors may be affected.

Humidity and temperature are the principal factors that influence the drying time. They are more controllable in the studio, where you can use a hair-dryer to make the paint dry faster, regulate the ambient temperature of your workspace or, if you wish, add some retarder gel to your colour mixes to extend the drying time. But on location it is best to accept the conditions, I think. When it is cold or humid and the paint dries slightly slower than usual, this isn't really a problem, as I can adjust my painting approach accordingly.

However, in hot conditions, because I choose to avoid the use of retarders, it can be difficult to paint in the normal way. So I adopt a different strategy: I either work on only a small area of the painting at a time, or use washes of colour and concentrate on reference studies.

Should you get caught in a shower, then the shelter of a large umbrella will allow you to continue painting. But be aware that a coloured umbrella will cast a tinted light on your work. Acrylic paints are water-soluble when wet, so it would be difficult to carry on painting with rain falling on the actual picture surface. However, dry paint is waterproof.

***Morning Ice,
Slimbridge,***
60 x 60 cm (23¹/₂ x 23¹/₂ in)
In order to recapture the cold light of this winter's morning in Gloucestershire I have used a narrow tonal range. Contrast comes from the cool blues of the ice and water against the golden warmth of the sunlit trees.

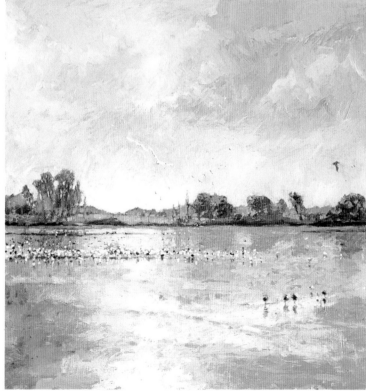

Weather and Light

For me, light is the crucial factor that enlivens a subject and inspires me to paint it and I suppose for this reason I am drawn towards sunlight, with its endless range of qualities. This isn't to say that I only paint summer scenes or confine my subjects to those that I find around the Mediterranean, although their allure cannot be denied! The weak winter sun can be equally inspiring, especially when it is reflected in water or in a wet surface, such as the paving in *San Marco* (below, right). And I know that even on dull days just a glint of light or a highlight somewhere can transform a scene and create wonderful possibilities.

In interpreting light, although it is sometimes desirable to exaggerate or manipulate certain effects in order to give the painting more impact, this should always be done from the starting point of observation rather than relying on invention. When there are dull conditions, for example, and the light is fairly even, it can be helpful to exaggerate the tonal range – to make the darks and lights more emphatic. On the other hand subtle differences in tone can sometimes work just as well, but may need the addition of an area somewhere in the painting that adds contrast. As a guide, if something attracts your attention and excites your interest in nature, then it should be possible to sustain this enthusiasm successfully in your painting.

The weather itself can be the inspiration for a painting – a sunset, a snow scene, morning mist and so on. Certain atmospheric effects will influence the intensity of colours and the illusion of space and depth. When there is atmospheric haze, for example, the water vapour in the air acts like a sort of filter, softening forms and reducing contrasts in colour and tone, making distant hills appear

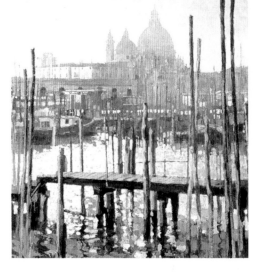

Landing Stage, Venice,
60 x 60 cm (23¹/₂ x 23¹/₂ in)
A cool mist coming in across the lagoon filters the milky sunlight and gives great depth to the scene, as the landing stages are enveloped one by one.

San Marco,
80 x 80 cm (31¹/₂ x 31¹/₂ in)
Colours often appear more vivid after a brief shower of rain.

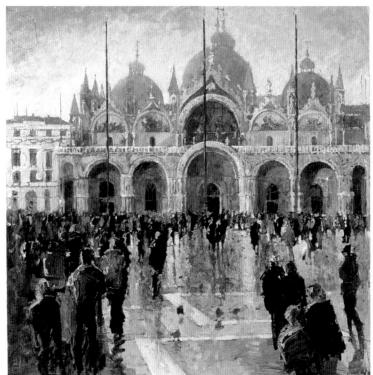

much bluer than they really are. This feature, known as aerial perspective, can be applied in a more general way to suggest depth in a landscape subject, but as always it should be related to the particular situation as observed, and not simply applied as a general rule in every instance.

74

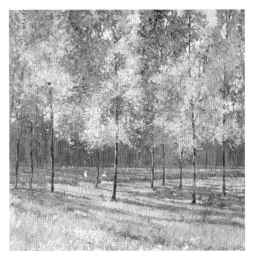

Return to Cuckoo Wood,
60 x 60 cm (23¹/₂ x 23¹/₂ in)
This is a favourite spot where I like to paint – a magical place, as the early misty sunshine begins to burn off the morning dew. The use of glazes and careful tonal observation helps convey the depths of hazy light.

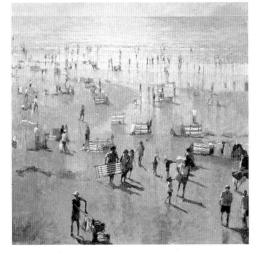

**To and Fro,
On the Beach,**
80 x 80 cm (31¹/₂ x 31¹/₂ in)
This beach painting demonstrates the use of aerial perspective, with colours and tonal variations becoming more muted in the distance.

75

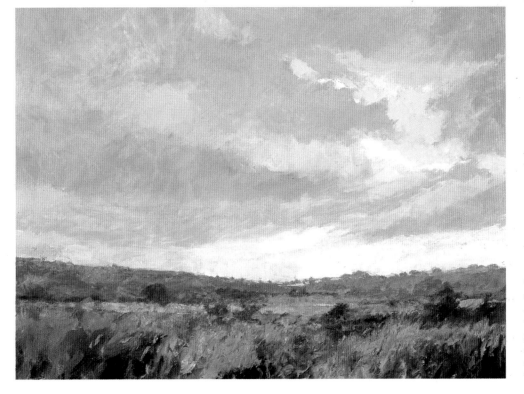

Golden Heath,
60 x 80 cm (23¹/₂ x 31¹/₂ in)
A strong breeze parts the rainclouds allowing a golden light to bathe the heathland, while the dark, distant hills tell of more rain to come.

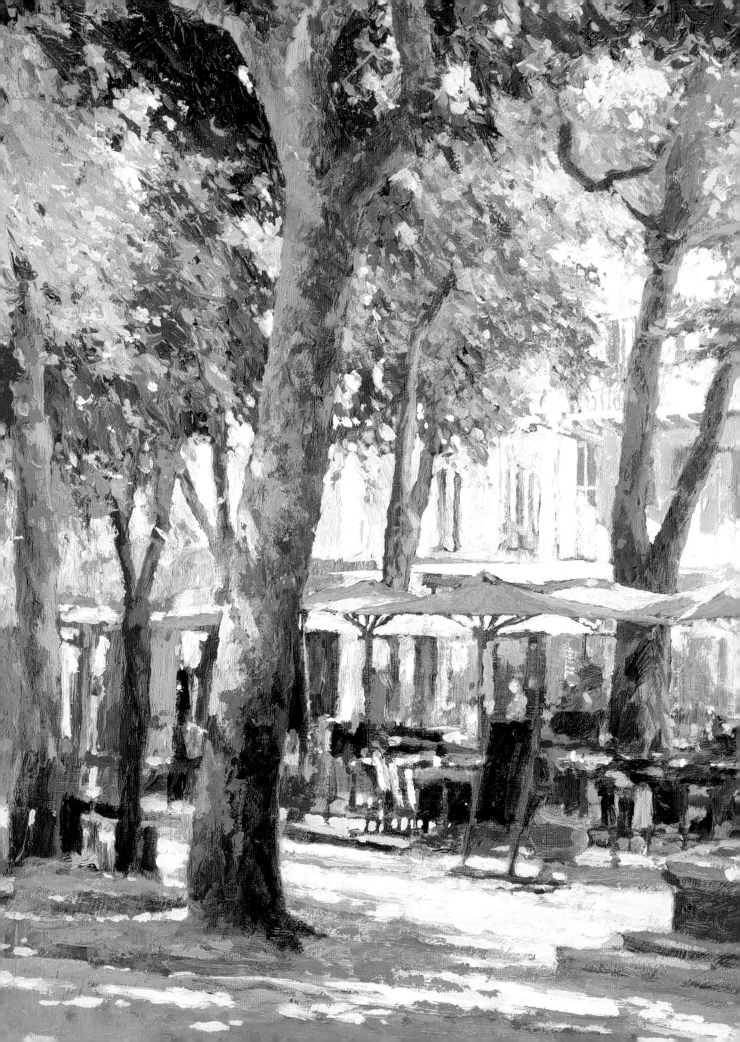

3 SUBJECTS AND INSPIRATION

There is an infinite variety of things to paint, and while it may seem that artists throughout the centuries have explored every possible type of subject matter, there is always scope for individual interpretation. Whatever the subject, however, I think it is important that it should excite you, so that you have a real desire to paint it. It should also present a challenge of some sort.

Tackling something that tests your ability and involves certain problems to overcome will not only widen your experience and help in your development as an artist, it is also more likely to lead to a better painting. There is little point in only painting ideas that you know will succeed, for this merely leads to lacklustre, tired-looking results. I like to be continually developing and widening my repertoire. My aim in every painting is that anyone looking at the finished work will experience something of the same excitement and sense of enjoyment that I had while I was painting it.

Cotignac Café,
60 x 50 cm (23¹/₂ x 20 in)

Choosing Subjects

Naturally, different subjects appeal to different artists, although most will agree that the subject matter does not have to be obviously beautiful, colourful or complex to work as a successful painting. Similarly, the choice should never be governed by pre-conceived notions about what makes a good painting: there is no magic formula. You should always feel free to attempt whatever inspires you and try out new ideas.

I never go looking for specific subjects. I may do some research before I set off on a painting trip, but this is just to locate an area that I think will offer the sort of subjects that interest me. Once there, I rely on exploring, looking and experiencing, all the time being receptive to any ideas that present themselves. Usually I find that I don't have to explore for very long, and that there is no shortage of ideas.

**Evening Flight,
Mallorca,**
*80 x 90 cm (31¹/₂ x 35¹/₂ in)
I have spent some time
painting on the north coast
of Mallorca. Contrary to
the accepted theory, I am
often struck by the fact
that distant mountains in
this region appear pink
rather than blue – a clear
demonstration that we
should always believe what
we see, rather than make
assumptions based on what
we think we know.*

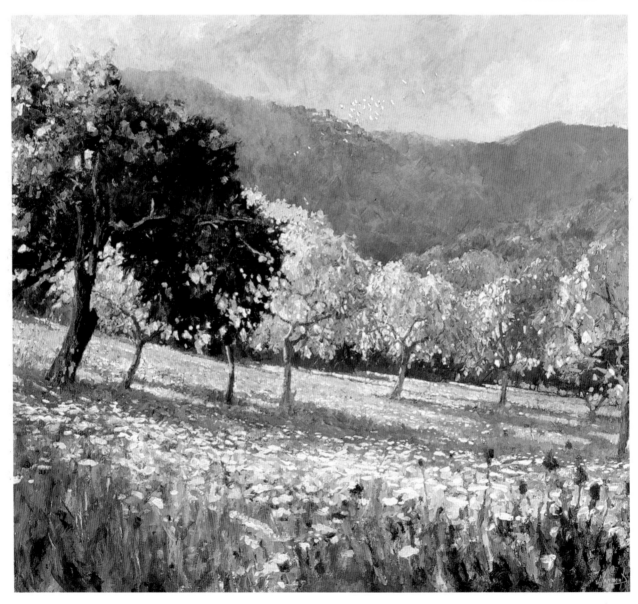

Variety and Development

In my experience one type of subject matter will lead quite naturally to another. I have always admired the work of the Impressionists and from a very early stage in my career I knew that this was the style of painting that I wanted to pursue. Where better to start, I decided, than by visiting some of the places where the Impressionists painted! This proved inspirational and successful: gradually, those places and subjects suggested other themes, ideas and locations to try.

This process has continued. A recent example is the sequence of paintings I have made of English pastoral landscapes. These actually evolved from some paintings I did of the River Gardon in France (see *Gardon Reflections* on page 32), which in turn led me to think about other rivers and later to begin a body of work inspired by the River Avon in Stratford-upon-Avon. Here, I painted at different locations along the river in the town, and eventually out in the countryside, where I started to focus my attention more on the landscape than the river, and hence develop the pastoral paintings. I think this shows that you don't have to consciously search for new themes. The more you paint, the more one idea will lead to the next.

In this way the scope of my work is constantly growing. Another aspect of this is that I try every year to develop in more depth one of the subsidiary ideas that has emerged from my painting, and so introduce an entirely new type of subject matter. Of course one advantage of this is that there is always something different for collectors and buyers, but there are equally important benefits for me and my work in general. Inevitably a new subject presents fresh challenges, particularly in the way the light and mood in each location must be interpreted.

Mostly my inspiration comes from the landscape and cities of southern Europe and the Mediterranean, while in Britain the main subjects are the coast and beaches of the South-West and the recent pastoral landscapes. I regularly sketch and paint in Venice, where I have gradually discovered very exciting and more personal subjects away from the obvious sites. This, I think, is something that happens as you gain more experience and you begin to respond in a more instinctive and emotional way to a wider range of ideas. My subjects usually include a human element: if not directly, in the form of figures, then by virtue of the fact that the fields are cultivated or there are animals or some other evidence of human involvement in the landscape.

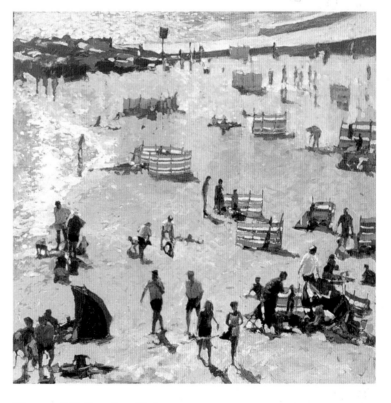

Figures and Shadows, Lyme Regis,
80 x 80 cm (31¹/₂ x 31¹/₂ in)
A high vantage point on the promenade offers the perfect viewing platform for this beach composition on the Dorset coast.

Moments in Time

Emotion is a very important quality in a painting. If you paint what you feel, this will show in the work. It will be more committed, expressive and successful. Usually my feelings and reactions to a subject are aroused by a quality of light or a similarly transient effect or chance encounter. So, my paintings are generally of subjects that I happen to come across at a particular moment in time. They present themselves, and in consequence I have to respond quickly.

New Year's Catch, Sidmouth is a good example. I was walking on the seafront at Sidmouth in south Devon on a bitterly cold New Year's day when a fishing boat came in

and the fishermen started cleaning the fish and selling them on the beach. The sunlight was wonderful, glinting on the sea and creating long, interesting shadows; everything was perfect about the scene. It was one of those moments when you stop and say 'I've just got to paint this'.

In fact I only had an exercise book and ball-point pen with me at the time, but this was sufficient to make a sketch (see right) and for some written notes about the colours. There is a similar story for *Evening Flight, Mallorca* (page 78), although here I was able to go back the next evening to record the scene.

Detail of New Year's Catch, Sidmouth, sketch, ball-point pen

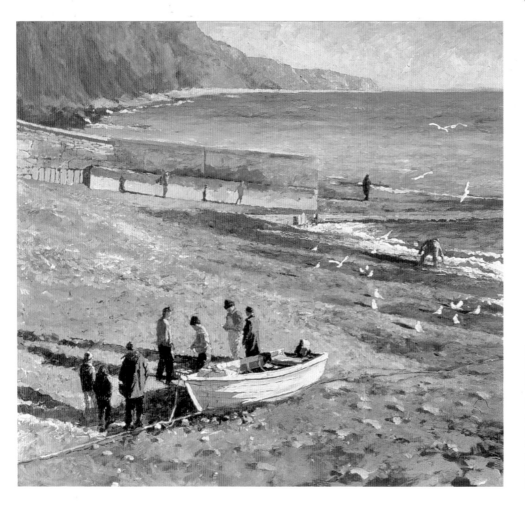

New Year's Catch, Sidmouth,
90 x 80 cm (35½ x 31½ in)
This perfect scene was lit by a low winter sun which cast long shadows and gave a golden glow to the colours. What better way to start the New Year than by finding subject matter as inspiring as this!

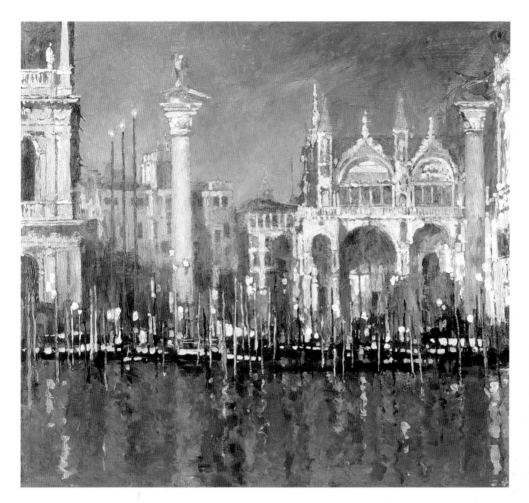

Piazetta San Marco,
80 x 90 cm (31^1/$_2$ x 35^1/$_2$ in)
*This classic view can only
be seen from the water.
Although I was fortunate
enough to have access to a
boat, I still had to work at
speed to gather the
reference material I needed
to complete this painting
later in the studio.*

81

Viewpoints

There are various factors that can influence the viewpoint you choose. Ideally you will want to find a view that creates a good composition and at the same time helps enhance the qualities you feel are important about the subject. But it isn't always possible to sketch or paint something from the spot you would ideally like, so inevitably some compromises have to be made. I don't worry if I cannot work from exactly the right place, because in my paintings I am more concerned with capturing the essence of the scene and what I feel about it rather than simply making an accurate copy. This leaves me free to interpret the scene as I choose, and also to use my experiences and memories as well as the location sketches.

Some artists carry a cardboard viewfinder to help them 'frame' the subject and choose the best viewpoint. You can make a simple viewfinder by taking a piece of card of about A5 size (A5 is 148 x 210 mm or 5^7/$_8$ x 8^1/$_4$ in) and cutting out a small rectangle in the middle. Like looking through the lens of a camera, this will help you refine your composition and decide what to include and what to leave out. But don't be afraid to manipulate the viewpoint if things such as passing traffic, crowds or the weather prevent you working in the best place.

Composition

It is generally true that no matter how well a subject is expressed in terms of colour and technique, if the underlying structure or composition is weak then the painting will not be a success. Often, decisions about the composition are based on both knowledge and instinct. But whatever process is used, the aim is to present the subject matter in such a way that it can be clearly understood by other people yet is also original and interesting to look at. The composition can work in a subtle way or it might be very obvious, perhaps itself forming the subject of the painting.

Basic Design

There are occasions when I make conscious decisions about the composition right at the beginning of a painting – often with architectural subjects, for instance, where it is essential to fix proportions and angles. *Façade, Venice* (right) was designed in this way. But normally I do not have a pre-conceived plan. Instead, the composition is a natural, intuitive process that starts with reference to the subject matter but then evolves to suit the effect I want in the painting. Generally, my approach is based on avoiding mistakes with the composition by adapting things as I go, rather than trying to work to a very fixed design – which in any case would tend to result in rather dull and uninspired paintings.

I obviously begin with certain lines and shapes in the initial stages of a painting, but I always regard these as things that can be altered, refined and manipulated as required. Good composition is all about considering one part in relation to another and making everything work within the whole, and it is

82

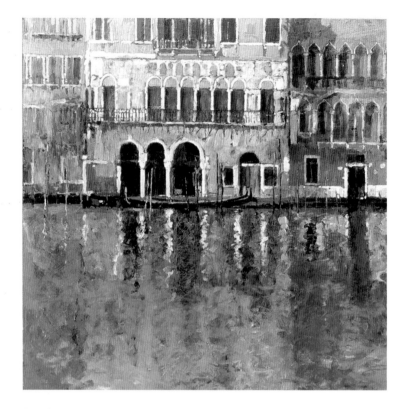

Façade, Venice,
90 x 80 cm (35¹/₂ x 31¹/₂ in)
I chose to compose this subject with a relatively shallow perspective because my interest lay in the intense colour and texture of the water's surface and the magnificent building reflected in the water.

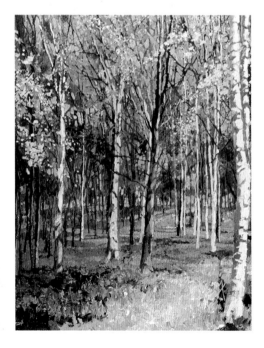

Through the Bluebells,
90 x 80 cm (35¹/₂ x 31¹/₂ in)
In this strong painting I have used colour and tone to give impact to a subject (bluebells) that is usually painted in a gentle and romantic manner.

seldom possible to achieve that straight away. So, I often have to move things around until they feel right. This process is demonstrated in *Through the Bluebells* (below, opposite), for example, where the gaps between the trees were adjusted and readjusted until I was happy with the overall effect.

A successful composition will hold the viewer's attention and help him or her discover the painting's meaning and individual qualities. Many subjects already have a naturally pleasing composition, and all that is necessary is to exaggerate or play down certain aspects to create the impact you want. Particular types of composition may appeal to you more than others. In my paintings I often use an 'S' or 'Z' design, which begins in the

foreground of the picture and leads the viewer into and around the subject, as in *Volterra Plains* (below).

In other paintings the key decision is where to place the horizon. It is generally considered to be bad practice to put the horizon straight across the middle of the composition, because this can make the design too balanced. Instead, many artists use a division that is based on thirds. Thus the horizon, for example, would be placed one-third or two-thirds of the way up the picture area. The 'thirds' method is in fact an approximation of the Golden Section, a specific mathematical ratio which is accepted as creating 'ideal' proportions (it is defined as the ratio where the smaller part is in the same proportion to

83

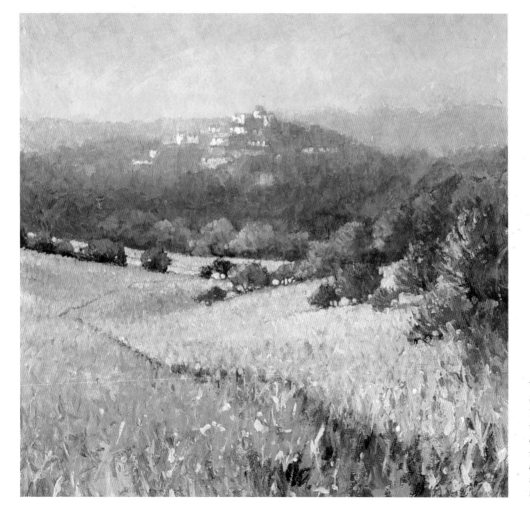

Volterra Plains,
60 x 60 cm (23¹/₂ x 23¹/₂ in)
These gently trodden, meandering paths that criss-cross the corn fields near Volterra in Tuscany are the perfect way to invite the viewer to step into your painting.

the larger part as the larger part is to the whole, which works out as 5:8). Artists have used the Golden Section, sometimes deliberately, sometimes intuitively, since Classical times.

Such theories can help in understanding balance, contrast and rhythm, all of which are important aspects of composition – but you should not rely on theories. What matters most is that the design looks and feels right, and that it works to enhance the idea you want to convey. You may think it useful to make one or two brief sketches to test out different composition ideas but, as I have said, use these as a starting point rather than something that will automatically determine the outcome for the painting.

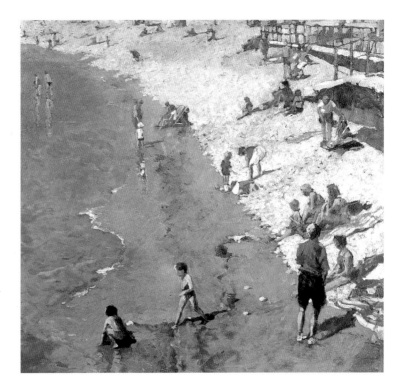

Shoreline, Sidmouth, 60 x 60 cm (23¹/₂ x 23¹/₂ in)
Unusually for a beach scene, the main compositional elements in this painting of the south Devon coast are vertical rather than horizontal.

84

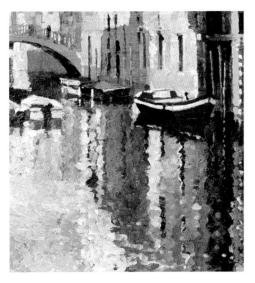

Venice Reflections, Castello,
30 x 30 cm (12 x 12 in)
A peaceful morning sees the vibrantly coloured working boats of Venice at rest for once. I have developed the composition so that the eye travels up the vertical lines of the reflections, along the diagonal line of boats, and so to the bridge across the water.

Winter Sun, Cotswold Lake,
60 x 60 cm (23¹/₂ x 23¹/₂ in)
A foreground 'window' perfectly frames this winter sunset scene.

On Location

Location work is invaluable as a means of experiencing and understanding landscape and associated subjects, as well as for studying the various effects of light. However, the conditions – and consequently the drawing and painting techniques – that apply when working on site will usually be quite different from those that are possible in the studio.

Something you soon learn to accept on location is that success very often depends on being adaptable, because the weather can change, people and vehicles can come along and block your view, and so on. Therefore sometimes you have to be prepared to abandon one subject and try another. Nevertheless sketches, even when only half finished, are always a useful source of reference, and will help stimulate your memories of the subject and what it felt like to be there.

Successful location trips also depend on good planning, including some research about the area to be visited and its climate. And there are various practical issues. How much equipment should you take, for example?

I usually have the full complement of sketching and painting materials with me (as specified on page 25), and if I also have the use of a car, carrying equipment around is not a problem. However, if you intend to explore an area mainly on foot, then it is best to travel light and carry only the essentials, perhaps in a rucksack. It depends on your aims for the trip. One approach is to concentrate on drawings and colour notes made in a sketchbook. When you return home or to your accommodation, you can then work on the sketches further or start on one or two paintings while the ideas and memories are fresh in your mind.

An aspect of location work that many artists find difficult, especially on their first few trips, is the fact that people are often inquisitive and will come across to see what you are doing. I used to look for corners and places where no one could stand behind me, but now I am much more confident and I don't mind if people stand and watch. But I try not to get involved in lengthy conversations; I politely say that I must press on with my work before the light changes!

85

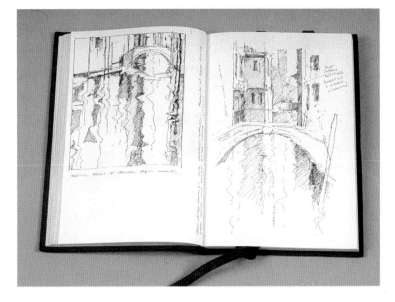

Rippling Reflections,
location sketches, pen and ink

Sketching Techniques

I work in a variety of ways to explore a subject and record the sort of information that I think will be useful when I come to begin painting. My sketching techniques include working in tone and line as well as making brief colour studies, but sometimes I also use a box easel (a small portable combination easel and brush box) and paint on small sheets of mountboard; if the weather and everything else is right, I may start the final painting on site. The amount of reference and preparatory work that I do for each painting depends on the subject and the conditions. For some paintings this work is quite extensive and may also include a reference photograph, as for *Rippling Reflections* .

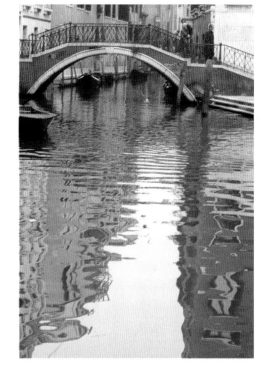

Rippling Reflections,
photograph

86

Rippling Reflections,
colour analysis of reflections

Rippling Reflections,
location study,
32 x 32 cm (12¹/₂ x 12¹/₂ in),
acrylic on watercolour paper

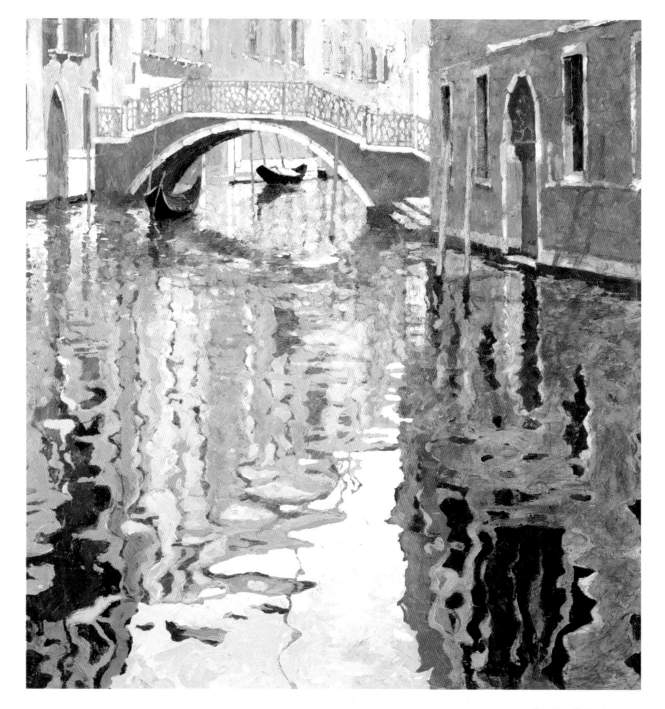

Not every sketch is made as the starting point for a painting. Often the aim of sketching is to help you analyse the content and qualities of a subject, to get you looking, understanding and making decisions about what you like, what excites you, and so on. Obviously this can be useful preparation work for a painting, but sketching can also be a worthwhile activity in its own right, as it helps to develop skills in observation, drawing and recording. I may return from a trip with around forty sketches, of which perhaps only six will be developed as paintings. But this doesn't mean that the others are less valuable; they all contribute to the learning process.

Rippling Reflections,
80 x 80 cm (31^1/$_2$ x 31^1/$_2$ in)
A large studio painting, based on much location work, this piece is predominantly an exploration of the abstract patterns caused by reflections on moving water.

Pencil Sketches

In most of my pencil sketches I am concerned
with tone rather than line. I find that
concentrating on tone is a good way to study
and understand the effects of light, and in
turn this helps me to interpret those effects
successfully in colour later on. Mostly I use a
B or 2B pencil when I'm travelling, because I
have found that sketchbook work in very soft
pencil can easily get smudged. I prefer a
slightly textured surface to draw on, often
choosing a Daler-Rowney Langton
watercolour pad, and I like to build up the
drawing with bold, vigorous blocks of tone,
using a putty eraser to pick out highlights.

Pen and Ink

Waterproof, fibre-tip pens containing
pigment inks are ideal for linear work and
they can also be combined with tonal wash, as
in *Budleigh Salterton, location sketch* (page 96),
or acrylic wash, as in *Barga, Tuscany* (page
35). I use pens of different widths, mostly for
quick sketches made with a variety of marks,
such as cross-hatching and scribbling, and I
prefer to work on cartridge paper. Here again
the sketches are a vital part of the looking,
thinking and selecting process.

Acrylic Sketches and Paintings

With any subject, another important aspect
to consider is colour. For quick reference
sketches in which I want to explore colour
relationships, contrasts and so on, I work with
acrylic wash (acrylic colour diluted with
water) on watercolour paper or one of the
papers manufactured specially for acrylics,
such as Daler-Rowney Cryla painting paper.
These sketches take the form of quick colour
notes; they are not for faithfully copying,
rather as something to stimulate my memory.

On location I sometimes also paint on
mountboard that I have previously prepared
with acrylic gesso primer. This gives me a
strong enough surface on which to build up
impasto, enabling me to paint in much the
same way that I do in the studio. These are
small, pochade-box studies and they help me
think about the texture and brush marks that
are appropriate for that particular subject.

Sunday Market,
Pollença,
sketch

88

*Sunday Market,
Pollença,*
photograph

*Sunday Market,
Pollença,*
90 x 80 cm (35¹/₂ x 31¹/₂ in)
*It is often the case that the
perfect viewpoint is hard to
find. Walking around a
subject allows the
opportunity to compose a
painting from more than
one aspect. My preferred
position to paint this
marketplace, at Pollença in
northern Mallorca, meant
that the beautiful round
window of the church
beyond was obscured by
foliage. But by working
from more than one
vantage point, and so in
effect 'editing' the view,
I could overcome
this problem.*

Landscapes

There has been a strong tradition of landscape painting in Britain since the 18th century, and certainly for those artists who are motivated by the effects of light and mood, landscape is a theme that offers immense variety and potential. I have always enjoyed looking at the work of the great landscape painters of the past and studying how different styles evolved and influenced one another. A notable example is the impact of the paintings of Constable and Turner on French landscape painting and the consequent development of Impressionism – the style that aroused my own interest in landscape subjects. In fact, with its concern for interpreting the transient qualities of nature and its emphasis on colour and paint handling, Impressionism has always been the style of painting with which I have felt most empathy.

Each landscape has its own special sense of place. The challenge in every painting is somehow to capture the distinctive qualities of that place, and in my experience the way to do this is to concentrate initially on observation and then selection. The character of a landscape, just like any other subject, is defined by various specifics. Through careful observation you can assess what these specifics are, and whether there are any elements of the subject that should either be emphasized or, on the other hand, reduced in impact or even edited out altogether. For me, all painting is a matter of interpretation based on personal decisions made about the subject as a result of careful observation and analysis.

Along the Otter from White Bridge,
80 x 90 cm (31¹/₂ x 35¹/₂ in)
Working from a bridge rather than from the riverbank can give a totally different perspective to a river painting, as in this view of the River Otter in east Devon.

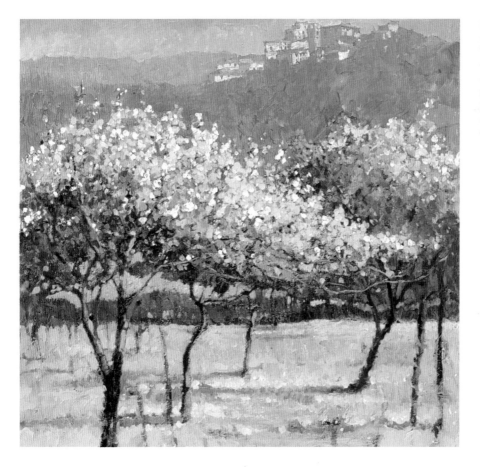

From the Orchard,
60 x 60 cm (23¹/₂ x 23¹/₂ in)
This orchard sits in a valley overlooked by the hilltop village beyond. The peaceful hours I spent painting here were counted by the toll of the church bells.

91

Space and Distance

There are two main types of landscape painting: the wider vista and the smaller, more intimate scene. A convincing sense of space is something that must be achieved in both types, but the challenge is how to create an impression of three-dimensional space when confined to a flat, two-dimensional painting surface.

Relative scale, linear perspective, aerial perspective and the use of particular colours and textures are all elements that can help in suggesting space and distance. Figures in different parts of a picture will suggest a scale, for example, while a receding fence or row of trees will have an inherent perspective, leading the eye further into the distance and so indicating the extent of the space involved.

And, as we have seen, certain atmospheric effects can influence colours, making them appear bluer in the distance, see page 74.

In theory, contrasting the detail and bolder colours of a foreground area with less defined shapes and much weaker colours in the distance will give a strong sense of space receding away from the viewer, but this isn't something that is necessarily appropriate to all subjects or how you may want to interpret them. In many of my paintings, for example, I find that suggesting space by using variations and contrasts of this type often works equally effectively the other way round – by focusing on something in the background and treating the foreground in a broader, less detailed way.

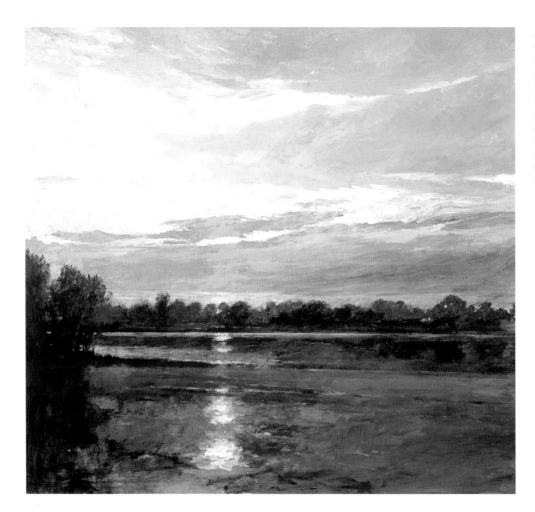

92

Skies

It isn't just how you interpret the features within the land area of a landscape subject that determines whether or not there is a convincing sense of space, for the sky is an integral element of that landscape and as such is equally important in a painting. Again, in theory, the colour of the sky appears less intense at its furthest distance from you, which is at the horizon.

Some landscape paintings are mostly sky and so, although they have to be based on reference and observation, they offer a good deal of freedom in the way that they can be painted. You can really experiment with the colour and texture of a dramatic sky, just as I did with *Sun Setting, Cotswold Lakes* (above). Whatever the type of composition, I will often start with the sky because it is almost always the most influential part of the subject in terms of light. I establish its principal tonal qualities and characteristics and then build up the rest of the painting in relation to this area, knowing that I can adjust things later if necessary. Sometimes this influence is a two-way process, with the sky reflecting colours from the land.

Foregrounds

The foreground is the obvious way into a painting and, being essentially the first point of contact between the viewer and the subject, it requires very careful consideration. It should therefore be inviting, and even if it is fairly busy in content and spans the width of the picture – as in *Summer's Brook* (right) – it must not be allowed to form a barrier. Instead, the aim is to draw the viewer's attention into the picture, though not by any noticeably contrived or laboured means. As with other aspects of composition, creating an effective foreground is as much a matter of avoiding things that detract as it is of making the right positive decisions.

In many of my paintings I aim to focus the viewer's attention on the middle distance and, if this is the case, I prefer an uncluttered foreground in which I rely simply on variations of colour and brushmarks to provide the necessary degree of interest.

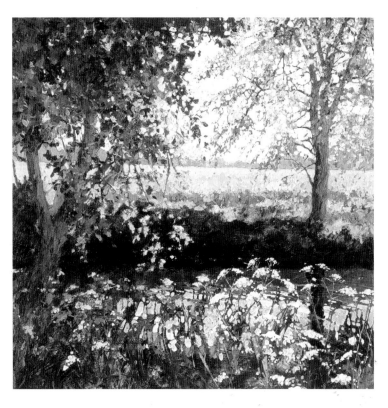

Summer's Brook, 60 x 60 cm (23¹/₂ x 23¹/₂ in)
I found this subject interesting because, despite the strength of tonal contrast and the vibrancy of colour, it was still a very restful scene.

93

**Golden Harvest,
Tuscany,**
60 x 60 cm (23¹/₂ x 23¹/₂ in)
I return to this area of Tuscany often in my paintings. The rich crops that come from this fertile sun-drenched landscape are overflowing with colour and texture.

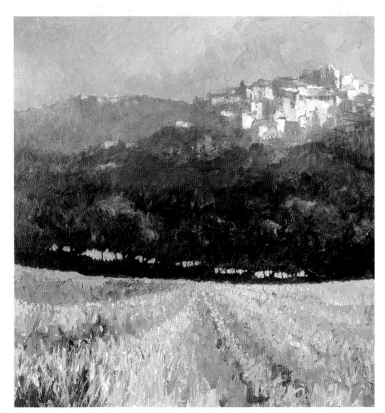

Colour and Texture in Nature

The immense variety of greens that you see in leaves, grasses and the other types of vegetation in a landscape subject can prove an extremely challenging aspect of colour to deal with. It is too simplistic to interpret foliage as being one kind of green, for example, or the sky to be a certain shade of blue, for colour in the natural landscape is as subtle and varied as in any other subject. The best advice I can give here is to encourage observation and analysis and to recommend that, as with the landscape in general, you look for the specifics. Living, growing things all have very individual shapes, textures and colours determined by growth patterns, the weather and the seasons of the year. Decide what it is that defines the colour or texture of a particular element and then choose the sort of colour mixes and brushstrokes that will enable you to depict those qualities.

The main thing to remember is to avoid preconceptions. Every green, for example, will be slightly different due to the way it is influenced by the light, the colours around it and perhaps other factors. I always mix greens rather than use tube colours and, as with any other colour, I continually assess and adjust their relative qualities and variations of tone and hue. In the finished work the greens can range from those that are almost blue to those with a strong red or yellow bias.

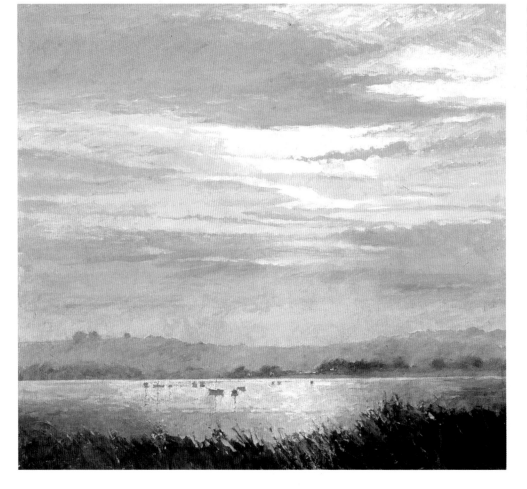

Golden Evening Tide,
80 x 90 cm (31¹/₂ x 35¹/₂ in)
My intention was to make this first and foremost a sky painting, but I couldn't resist the patch of light reflecting off the water and it soon became a very important element in the composition.

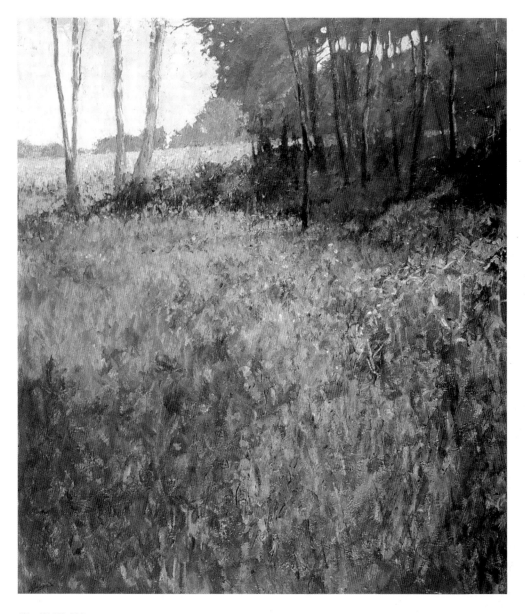

The Field's Edge,
90 x 80 cm (35¹/₂ x 31¹/₂ in)
*In this painting, taking
advantage of the drying
properties and versatility of
acrylic paint, I quickly
built up a heavy texture
from layers of glazes and
impasto work. This corner
of a field, although only a
detail of the whole
landscape, seemed to sum
up my thoughts and
feelings about the
surrounding Devon
countryside.*

Boats and Beaches

Beaches are one of my favourite sources of subject matter because they are places where I can find all the pictorial elements that most interest me – atmospheric effects, people and activity, as in *The Parasols* (right centre). With the changing qualities of light – in the sky, the sea and perhaps reflected on the wet sand – and the constant movement of people, no two moments on the beach are ever the same. I can sit and draw all day, selecting from the continuous supply of subjects in front of me. As well as numerous figure sketches I make studies of the light and the scene in general, and then, some time later in the studio, I work from this copious resource material to encapsulate my memories and experiences in a painting or a sequence of paintings.

Boats also provide interest and activity on the beach and, given the right viewpoint, they make very exciting subjects to paint. The boats at Beer, for example, shown in *Summer Boating, Beer* (bottom right), appealed for this reason, and the shape and position of these boats created a strong, dynamic composition. Additionally, in my river and harbour paintings it is often the reflections of the boats that particularly attract my attention and, as demonstrated in *Evening Glow, Venice* (opposite), these can become the main feature of a painting.

Budleigh Salterton, location sketch, pen and wash
Quick sketches like this one in south Devon help with observation and exploration of potential subject matter.

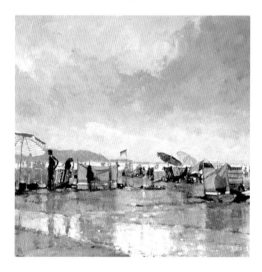

The Parasols,
80 x 90 cm (31¹/₂ x 35¹/₂ in)
Despite being quite crowded, this beach still had a wonderful sense of space. In order to convey this feeling I chose a low viewpoint, thereby condensing the people and their windbreaks and parasols into a band of activity, contrasting with the expansive sky and empty foreground.

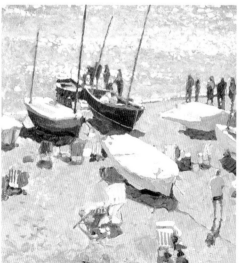

Summer Boating, Beer,
40 x 40 cm (15¹/₂ x 15¹/₂ in)
Another south Devon beach scene, this time seen from the headland above the bay. Working from a high vantage point tends to flatten the picture surface, allowing me to look for patterns and shapes within my composition.

96

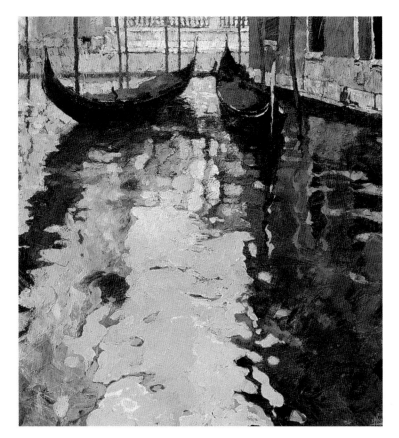

Evening Glow, Venice,
40 x 40 cm (15¹/₂ x 15¹/₂ in)
The advantage of using acrylic paint for a difficult subject such as water is that it allows you a great deal of flexibility and control, so you can always modify or rework certain areas of the picture if necessary.

Water

Like skies, water is something where the influence of light is very obvious. A stretch of water will mirror the light above and, depending on the nature of its surface, it can define that light in many different ways. In some instances the water itself becomes the principal source of light and in consequence the main area of interest in the painting.

Water can vary considerably in its character and appearance. Although it often looks transparent, there are reflections, and it is moving – all of which are difficult qualities to express in paint. However, acrylic paint does enable a great deal of flexibility and control when painting transient effects such as water, so it is possible to adjust and rework areas if necessary. The important point to realize is that it isn't essential to use diluted washes of colour. You can paint water in much the same way that you would paint any other surface, and this can involve working with the paint in quite a textural way.

I do not have a special method for painting water. As always, I start by observing the qualities and features that are pertinent and individual to the subject so that I can focus on these aspects in the painting. In this case I look for the particular character of the water – whether it is smooth, rippled, rough, dark, light and so on – and from this I decide which colours and types of brushstroke will be the most suitable to help me portray those characteristics effectively. I work with quite deliberate patches and marks of colour rather than layers or glazes, but sometimes I add glazes later if I want to give the colour greater depth or transparency.

97

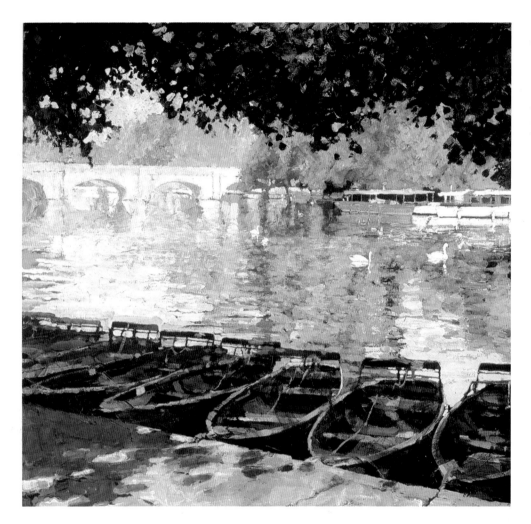

**Late Summer,
Stratford-upon-Avon,**
60 x 65 cm (23¹/₂ x 25¹/₂ in)
*I have produced a number
of paintings along this very
English river. Here the
repeated shapes of the row
of boats sitting in the shade
required careful drawing.*

Reflections

I regard reflections as an integral part of the water surface and I paint them as such. In my view, starting with the reflections and then trying to superimpose an impression of water, or alternatively adding the reflections on top of the water, are methods that never work very convincingly. The fact is that a reflection is not a shape that can be treated as something separate from the water because what you are actually seeing is part of the same surface. It only differs in that it is water influenced by other shapes and colours. Another interesting point concerning reflections is that they tell us a great deal about the nature of the water, for example whether it is still or fast-flowing. In the case of moving water, it isn't possible to record something seen in a split second, so my approach is to spend some time just looking and trying to understand the rhythms and patterns. Moving water, particularly in rivers and streams, usually has a degree of repetition, in which fluctuations from moment to moment are contained within a broadly constant pattern. This sort of observation will inform your drawing and help you capture the general character of the water. You will also notice that in moving water the reflections are broken in outline and somewhat distorted, whereas in calm water of course they can appear almost as an exact mirror-image.

City Views

My interest in architectural subjects developed as a natural progression from my landscape work. While some similar elements are involved, especially in urban landscape paintings (views which include leafy squares and open green spaces), there are other qualities that are quite different and so provide fresh challenges. I suppose the main difference when painting city views is that the human presence is more obvious in most of the subjects and that a more disciplined approach is usually required, with a greater emphasis on draughtsmanship to convey the detail of the architecture.

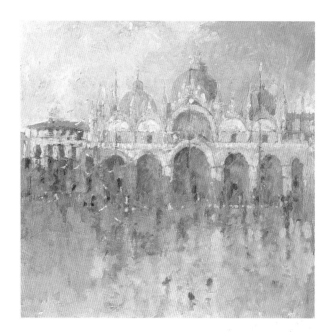

San Marco Gold,
30 x 30 cm (12 x 12 in)
I love the freshness of this small, quickly painted study, which shows the importance of capturing the underlying structure of buildings, however ornate they may be.

99

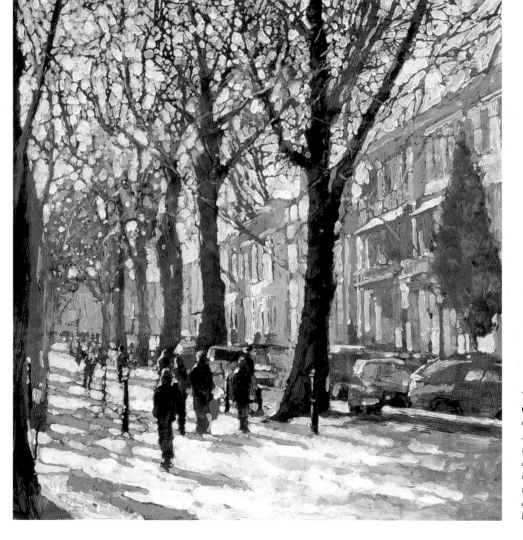

Winter Sunlight, Cheltenham,
60 x 60 cm (23¹/₂ x 23¹/₂ in)
Although I could take my time to record the architecture and the shape of the trees for this picture, the bright light and its effect were quickly gone — but not forgotten!

Drawing

Naturally, light and mood continue to be important qualities in my paintings of Venice and other cities but, unlike the landscapes, I cannot rely as much on working from memory. While I am not striving to copy faithfully every detail of a building, there are certain elements that have to be correctly recorded. Consequently there is a greater reliance on drawing, both in the exploration and preparatory material and in the preliminary stages of the studio paintings, where it is essential to have a reliable underdrawing to work from.

This is not to say that my time on location is spent laboriously counting the number of brick courses in a façade or drawing every window! I can take some photographs to show me all the architectural detail that I need. Location time is valuable and the best way to use it, I think, is to concentrate on the qualities that a camera cannot record: your impression of the light, the sense of place, and the features that define the subject and the moment. Usually my method is to sketch and note these things when I first discover the subject and then, if possible, return very early the following morning (when there are few people about) to make some pen drawings of proportions and general shapes, as well as to take documentary photographs.

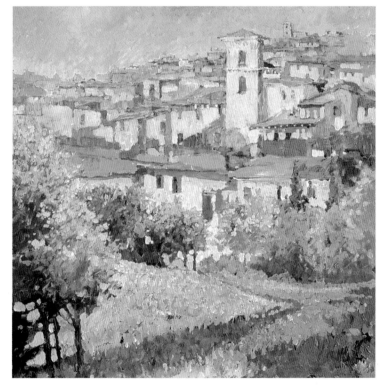

A Quiet Corner, Vaucluse Village,
60 x 60 cm (23¹/₂ x 23¹/₂ in)
This hillside village in the Vaucluse département of southern France, with its terracotta tiles and sun-bleached walls, radiates the heat of a Mediterranean summer's day. The rooftops become an almost abstract patchwork but are punctuated, and so given context, by little touches of architectural detail.

100

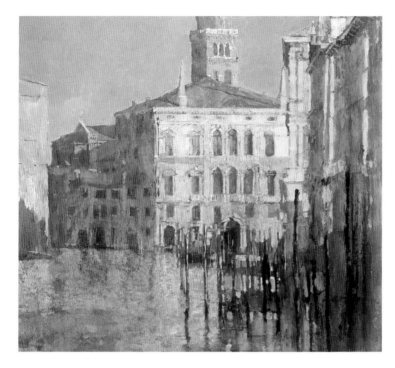

Palazzo Balbi,
80 x 80 cm (31¹/₂ x 31¹/₂ in)
In Venice, at La Volta, the Grand Canal turns sharply, revealing the glorious sunlit façade of the Palazzo Balbi. The aim in this painting is to capture the overall impression of the architecture, without getting caught up in the specific details.

Perspective

A knowledge of perspective is essential when you are painting buildings. However, this doesn't necessarily mean that you have to use lots of construction lines and vanishing points to help you plot the different angles and proportions. If the subject is very complicated you may well want to start with a few guide lines, but what is more important is that you always draw with an awareness of perspective, so that you are conscious, for example, that receding parallel lines must converge. The best approach is to combine this awareness with decisions based on your own careful observation of the subject. I sometimes place a ruler against an outline to check whether it is straight and occasionally I also use a plumb-line to check vertical lines in my paintings. These devices are helpful only as a guide; drawing perfectly straight lines is never my intention. Fresh and slightly loose lines invariably look better, though obviously if the side of a building is perfectly straight in your subject it shouldn't look too meandering in your painting.

Selection

In many city views it simply isn't possible to paint every architectural detail, nor indeed is it always necessary to do so. When I am painting ornate buildings, as for example those shown in *Palazzo Balbi* (above), my first and main concern is always for the general character of the subject rather than the specific details. I look for the features that identify the particular building and concentrate on those.

Too much emphasis on details can be a distraction. Occasionally there are details that seem important to the painting and the way I want to interpret the buildings, however, and so I include them. But rather than seeking to produce an architect's blueprint, I am looking to 'describe' the ornamentation by the use of fluent, simple brushstrokes that suggest the detail and keep it in harmony with the rest of the picture.

Mediterranean Light

My first trip to the Provence region in southern France, was in 1986. Inspired by the work of Van Gogh, Cézanne and other artists who had painted there, I had decided that I would like to experience for myself the special qualities of light and colour that are found in this region. With its vineyards, olive groves, lavender fields and varied, undulating landscape, all of which were bathed in a warm, steady light, Provence was a revelation, and I have revisited the area regularly ever since. The subjects that I discovered in Provence have gradually encouraged me to try similar themes in other countries of the Mediterranean, and I now paint the vineyards and countryside of Tuscany, for example, and I also find ideas in parts of Spain.

Certainly in summer, the blue skies of the Mediterranean perfectly complement the predominantly ochre, earth pigments found in the landscape, and even the shadows are beautifully coloured. For me, another attraction is that everywhere you look, even on the smallest patch of ground, vines, vegetables and other produce is being grown. People believe in the land and they look after it. This human connection with the landscape is something that has always interested me, and it is a quality I like to convey in my paintings.

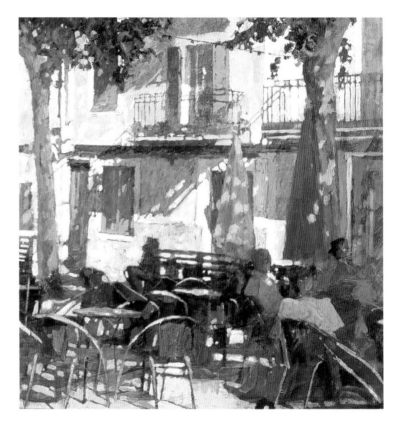

Bunyola Café,
40 x 40 cm (15¹/₂ x 15¹/₂ in)
I have returned to this café more than once to shelter from the Mallorcan sun. A very welcome resting place for a glass of fresh orange juice, I love to sit here and sketch or just watch the world go by. In this painting I have used strong, complementary colours to add vibrancy to the image.

There is also an interesting interaction of light and colour in the cities, and these have become another exciting source of ideas for me. However, in addition to aesthetic and artistic reasons for wanting to paint subjects bathed in Mediterranean light, I like the bonus that, for much of the year, the climate is fairly reliable. Therefore, from a practical point of view, it is possible to do plenty of work on the spot. And this means that, as well as collecting the usual wealth of reference material, I can start or even complete some paintings on site.

Colour Temperature

Because the contrasts of light and shade are more marked in this region, the shadows are more apparent, and consequently they can play a significant role in the composition of the paintings. But despite the fact that the light is generally strong and bright, producing clearly defined shadows, it can also create quite sensitive effects in the subject, with shadows that are full of reflected light. In *Vente de Lavande* (below, right), for example, there is a noticeable dark shadow under the tree, in contrast to the bright field beyond. But it is a shadow sparkling with light and colour.

As we have seen, colour is the principal means of interpreting light. But at the same time it can also suggest temperature, and this is something that is particularly relevant to painting Mediterranean subjects. Combined with experiencing the feeling of light and space in these paintings, I want the viewer to sense that a shaded area, perhaps under a tree, is a cool place to be, while in a sunlit field it is much warmer.

I try to achieve these effects by carefully considering the colour mixes I need and the most suitable method of applying the paint for each area of the painting. All colours can be heightened or subdued depending on how they are mixed. A blue, for example, needn't be a cool colour. It can be warmed by mixing it with a touch of red and then, depending also on the surrounding colours, it will look quite vibrant. I work from the same basic palette that I normally use, although the emphasis on particular colours and colour mixes will be different. Typically there is a predominantly blue influence in my Mediterranean paintings, but each theme defines its own colour range.

Vente de Lavande,
60 x 65 cm (23¹/₂ x 25¹/₂ in)
Pausing to buy lavender oil distilled at the nearby farmhouse, I was glad of the cool shade of the trees – a feeling I have tried to convey in my painting. Notice how glazes are used to bathe the sunlit areas in warm light.

103

Volterra Light (stage 1)

*As with many landscapes this painting does not
require complex drawing. A few lines indicating general
composition and scale suffice.*

Volterra Light (stage 2)

*The rich earthy hues of this Mediterranean landscape are
intensified by the bright sunlight. I work quickly to cover
the white ground and so begin to establish the depth of
colour I require.*

Volterra Light (stage 3)

*I have painted in this region before and know that the
brilliant Italian summer sky will have a powerful influence
on other colours within the composition. For this reason
I am keen to establish the swathe of blue and its relationship
to the treeline and buildings that interact with it. Notice
how I have brought touches of this blue down through the
cornfield and into the shadows to give unity and intensity to
the picture surface.*

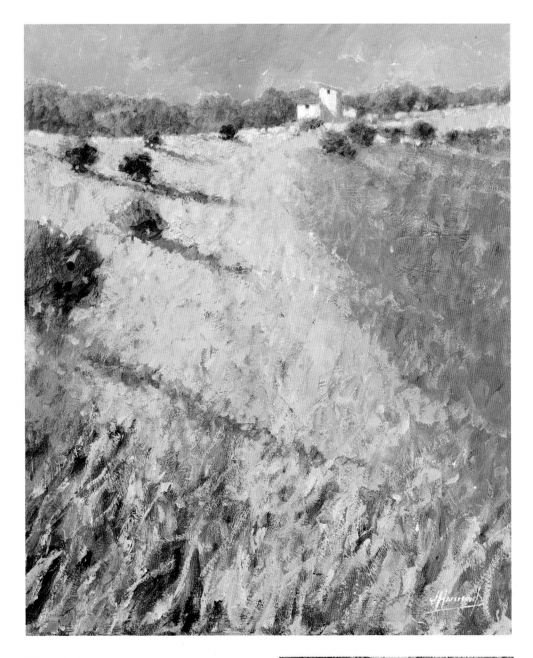

Volterra Light,
35 x 30 cm (14 x 12 in)
*The completed painting captures the heat of the Volterra
sun just as I remember it. Accents of blue and lavender in
the raking shadows combine with touches of lemon and
violet to convey the shimmering quality of the region's
dazzling light.*

Volterra Light (detail)
*In this actual-size detail you can see how I have increased
the texture of my brushstrokes and the vibrancy of the
colour in the foreground to give a sense of depth, as I
continue to build up layers of broken colour.*

Figures

There are various ways in which human figures can contribute to the impact and success of a painting. They are a good compositional device to attract the viewer's attention and direct them around the painting; they provide a sense of scale; and they are a useful means of adding a narrative element, movement or interest.

In some of my paintings the figures are an important part of the composition right from the start – indeed they might be the initial inspiration for the work. On other occasions I may include figures at a much later stage, perhaps to give weight to the composition or because I have decided that the content of the painting needs a little more interest. But whatever reason for including figures they must fit into the subject and context convincingly. This is why I never invent figures for my paintings. Instead, I always base them on sketches and studies I have made at the same location as the painting or somewhere quite similar.

106

Figures
sketchbook study
Without using a posed model, these quick studies are often the only way to record figures that you plan to include in your paintings. Although drawn at great speed and often incomplete it is surprising how much useful information they can convey.

Observing Figures

Wherever I go I try to spend some time observing and sketching figures, and in this way I have built up a useful quantity of resource material that I can refer to when I want to add some figures to a painting. These sketches are mostly quick line and tone drawings made with a pencil or pen. The aim is to capture various poses and different types of figures – people walking, running, drinking coffee, standing in groups, shopping and so on – concentrating on the overall impression of the person being sketched rather than trying to make a detailed portrait study.

Figures are certainly one of the most difficult subjects to sketch and paint. But, as I have found, it does get easier as you become more experienced at looking, understanding and knowing which aspects to concentrate on. The main thing is to trust your eyes rather than your knowledge of figures and to concentrate on the basic shapes, proportions and angles, interpreting these with an economical use of line, tone or colour. Life-drawing classes can be a tremendous help in this respect. I still regularly attend such classes because I think life drawing is an invaluable discipline, not just for figure work but for practising and developing drawing skills in general.

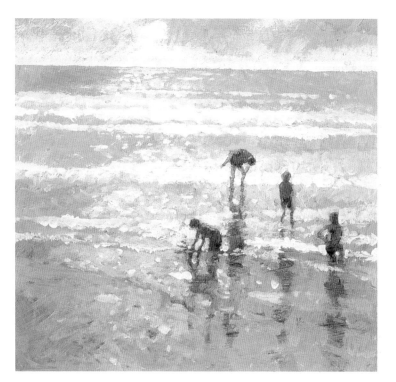

In the Shallows,
30 x 30 cm (12 x 12 in)
Even when painting in the studio from drawings made earlier, the important thing for me is to carry the feeling of spontaneity and animation in my figures through to the completion of the painting.

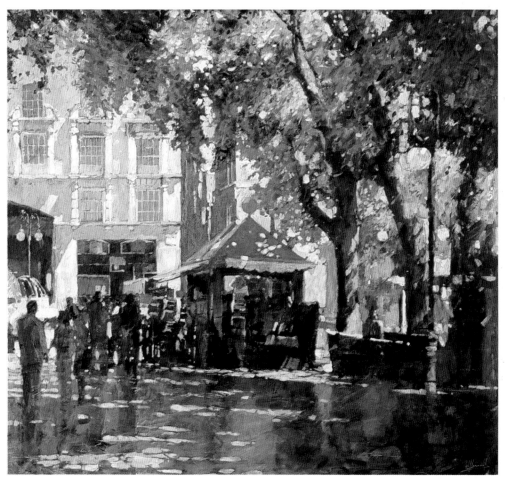

Passieg des Born, Palma,
80 x 80 cm (31½ x 31½ in)
By including the figures, I have given this townscape a focal point and a better sense of scale.

Crowds

When I paint a crowd scene, like the one shown in *Piazza del Campo, Siena* (below), I look for patterns and rhythms, and I try to view the crowd in terms of an overall shape and mass, not as a collection of individual people. In fact I adopt a very similar approach to the method I described on page 97 for painting flowing water. I start by sitting and looking, noticing how, within a large, open space, people tend to follow certain directions and congregate in different groups. Again, my aim is to create an impression, a suggestion of the scene, and I try to achieve this with a series of marks and patches of tone rather than thinking about particular heads, bodies and so on.

Figures and Composition

It is very important to consider exactly where figures should be placed in a painting to produce the desired effect. When planning the composition, a figure or group of figures will make a strong and interesting focal point, but alternatively they can be used in a more subtle way to create a sense of movement around the whole of the painting and contain the viewer's attention within the picture area.

Something else to check is the size of the figures in relation to their surroundings and, of course, in relation to figures in other parts of the painting. In fact changes of scale made in this way, from large figures in the foreground to much smaller, less distinct ones further back, will help you suggest a convincing feeling of space and distance, as in *Lyme Regis* (below, opposite). But not every painting needs figures; where the mood of the landscape is tranquil, for example, and the subject works as an effective composition in its own right. And on other occasions it is enough just to imply a human presence, as I have done by including the bicycles in *Midday Pause, Pollença* (above, opposite).

108

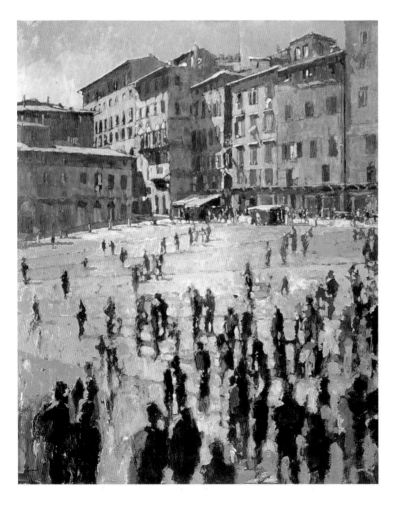

**Piazza del Campo,
Siena,**
80 x 90 cm (31¹/₂ x 35¹/₂ in)
The moment I walked into the large bowl-shaped piazza in Siena I was reminded of one of my beach paintings, for scattered across the square were groups of figures at rest and play. The shapes and patterns of movement they made seemed so familiar, and I have since completed a number of paintings here exploring these similarities.

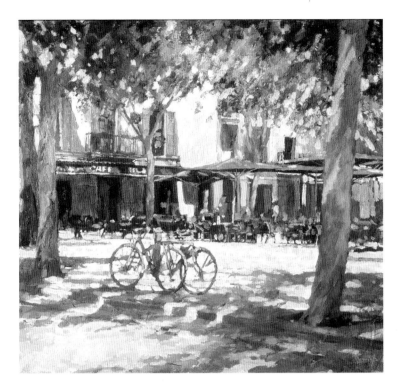

**Midday Pause,
Pollença,**
57 x 60 cm (22¹/₂ x 23¹/₂ in)
*It isn't always necessary
to include people in a
painting to give it human
interest. Here, two
bicycles were left in the
shade of the trees as their
riders took a rest at a
nearby café.*

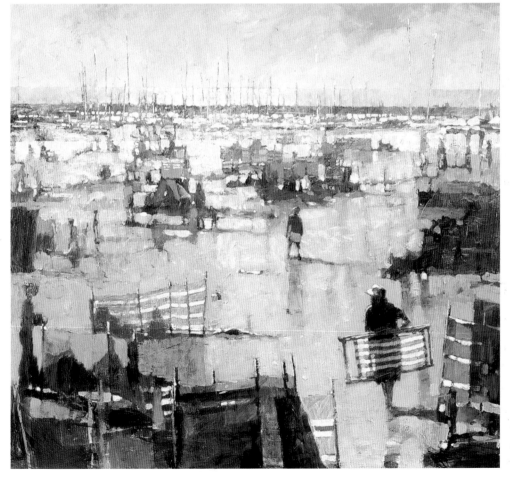

Lyme Regis,
90 x 80 cm (35¹/₂ x 31¹/₂ in)
*I enjoy painting the
activity and movement of
holiday makers as they
make themselves at home
on the beach, carrying
deckchairs, erecting
windbreaks and playing
games. A real exercise in
showing the human form
in motion.*

4 DEVELOPING IDEAS

I like to paint on site whenever I can, and if the conditions are favourable I will continue with the painting until it is finished. However, if my time at any given location is limited, I prefer to concentrate on sketching and collecting information on as many different subjects and ideas as I can, rather than aiming for perhaps one or two resolved paintings. Therefore, many of the paintings that I exhibit and sell are produced entirely in the studio, inspired and informed by the reference material I have collected on my trips to the Mediterranean and other places.

As well as the time factor there are of course practical things to consider when painting on site, not least the reliability of the light, and the weather. Generally, those paintings that are made on location start out as colour reference studies but, because everything is going well, I carry on working and the study develops into a finished painting in its own right. Usually these paintings are no larger than 40.5 x 40.5 cm (16 x 16 in) and ideally I like to finish them in a single session of work, although sometimes it is possible to return to the same place the next day. Additionally, there are some paintings that I start on site but finish in the studio.

With their necessary emphasis on speed and spontaneity, my location paintings are often slightly looser and more impressionistic in technique than the studio pictures. There is more time in the studio to consider decisions and working methods, although my emphasis is still on painting with feeling and vigour. I find that the best subjects for a *plein air* approach are those that are less complex in terms of drawing – so landscapes are more suitable than complicated city scenes.

111

Long Meadow, Provence,
35 x 30 cm (14 x 12 in)

Working from Sketches and Photographs

I don't have a fixed approach for working on site. Invariably the sort of work I do is determined by my response to the subject matter and how I think it can be developed into a finished painting. From my many years' experience in gathering ideas and information on location I can now assess very quickly what will be the most useful type of reference material for the painting I have in mind. I believe it is important to develop the ability to use time spent on location efficiently and effectively.

This sheet of sketchbook studies for *Vibrant Water, Blue Gorge, Mallorca* shows one way that I might begin to explore a subject, and in this case I also decided that a small colour study would be useful. For general reference, I also took a photograph (see page 116). In the sketchbook drawings I concentrated mainly on the basic composition, adding written notes about key colours, shadows and light effects. When I return from a location trip I will have a quantity of reference material of this kind to use as the inspiration for my studio paintings. I

begin by looking through all the material, reacquainting myself with the subjects and locations that I visited. I spend some time on this, and what I am hoping is that, as happens when I am on location, something will attract me to a particular subject to rekindle my interest and excitement, in other words, that an idea will present itself. This will be the idea for my first painting.

The next step is to prepare the studio. I pin up all the relevant sketches and photographs around my easel, plus any others that are of similar subjects and which may contain additional useful information. My aim is to recreate something of the atmosphere of the place that originally inspired me. Sometimes I also bring into the studio various things associated with the particular place or subject. For example, when I am painting lavender fields the scent from one or two bunches of dried lavender can be very evocative. Once the painting process in the studio is underway, one painting seems to lead quite naturally on to the next.

112

Vibrant Water,
Blue Gorge, Mallorca
preliminary sketches

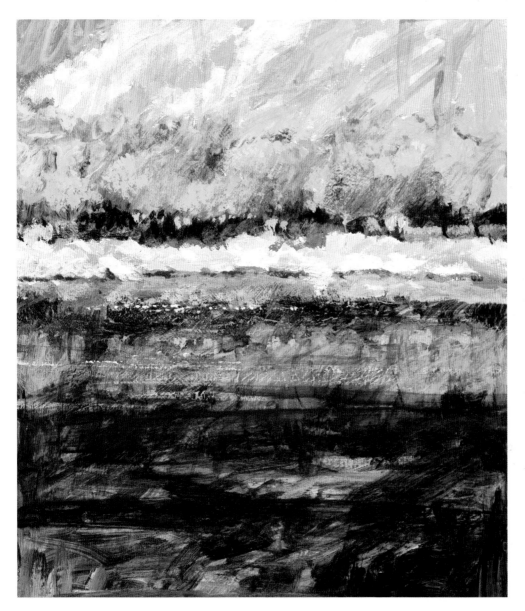

**Vibrant Water, Blue
Gorge, Mallorca**
location study on
mountboard,
25 x 22 cm (10 x 8$^{1}/_{2}$ in)

114

Sketches and Composition

The way I compose the paintings from the original sketches varies from subject to subject. Sometimes I work from just a single sketch and use exactly the same composition. This was so with *Vibrant Water, Blue Gorge, Mallorca* (opposite), in which the only major compositional decision to consider before starting the painting was where to place the line of trees. Otherwise, as you can see, the painting follows quite closely the design in the first sketchbook drawing, shown on page 112. I find it is quite often the case that the first, instinctive idea about a subject is the one that works best as the composition for the studio painting. But it is important never to take that for granted, and I know that alternative ideas and additional pieces of information can all play their part in developing a convincing painting.

A different approach I sometimes use is to work from a variety of location sketches and colour studies, selecting particular ideas and images from each one and so creating a composite design. I do not feel it is necessary to make any preliminary composition drawings of this composite design as such. Instead, I draw directly onto the prepared MDF support. I start with one or two pencil lines to identify the key shapes, and develop the composition from that – very much on the basis of finding my way as I go. But whatever the approach, I always regard the composition as something that can be altered at any stage in the painting should I think it necessary. You must respond to what is happening in the painting, and like the painting itself, the composition should show a certain freedom and spontaneity.

115

Vibrant Water, Blue Gorge, Mallorca,
80 x 80 cm (31¹/₂ x 31¹/₂ in)
From the first moment I saw this view I knew that I wanted to produce a large painting in order to give the sense of scale of this reservoir in the northern mountains of Mallorca. For this reason I spent considerable time collecting information, drawing and painting a number of studies on site. I believe the finished painting captures perfectly the atmosphere of this truly magical place.

Reference Photographs

In my experience photographs cannot provide all the information required for a painting, although sometimes they are useful as supplementary reference material. Their value for the painter lies, I think, in collecting factual information, particularly the sort of repetitive detail that would take a long time to record by drawing. When painting *Vibrant Water, Blue Gorge, Mallorca* for example, the photograph was a helpful reminder of the scene in general, but my sketches proved the most important source of information, because they focused on the features and effects that I thought were most telling about the subject.

Photographs can give a false or exaggerated impression of qualities such as distance and, if they are the sole form of reference, there can be a temptation to copy detail and so produce a painting that is fussy and overworked. That said, there may be times when you do not have your sketchbook with you and the only means of recording an interesting, chance idea is to photograph it. This has happened to me on one or two occasions and, very rarely, I have made a painting working only from a photograph I have taken.

In this situation, in addition to taking the photograph, I also like to spend some time studying and absorbing the subject. I think my way through the procedures that I would adopt if I were sketching it, and I try to impress on my memory the important qualities of the subject. For this reason I would stress that when photographs are used they must be your own. If you were there, taking the photograph, you should be able to recall something of the mood and atmosphere of the scene, and you can use these memories to supplement any information that comes from the photograph.

The fact that photography is a quick information-gathering technique can be a benefit, but obviously it should not be something that you come to rely on. In my opinion it can never be a substitute for sketching on site which, as well as providing selected, pertinent reference material, focuses your mind on the subject for a reasonable period of time, helping you to understand and remember it.

Vibrant Water, Blue Gorge, Mallorca photograph

Studio Paintings

My studio work covers a variety of
approaches. Some paintings are unique in
the sense that they are inspired by a chance
incident or subject matter that could never
be repeated, as with *New Year's Catch,
Sidmouth* (page 80). Others may belong to a
succession of paintings developed from a
common theme, or are associated with a
theme that I regularly return to, such as the
lavender field paintings shown on pages 68
and 69. And there are also some paintings
that evolve quite naturally from previous
works because, during the process of painting
the initial idea, I have discovered other
aspects of the subject that I would like to
explore further.

Essentially, my aim for every painting is to
convey the qualities of the subject that most
impressed me, as well as to express a
convincing sense of mood and place. In
consequence, every painting is different, and
each has its own identity. It follows that to
achieve the individual characteristics and
demands of each subject there can be no
single way of painting, no set procedure.
Indeed, if there were, painting would be
reduced to a routine rather than being the
exciting, challenging and very rewarding
activity that it is.

However, there are certain general stages of
development that are common to many of
my studio paintings. These are now
explained in some detail, with particular
reference to the step-by-step demonstration
painting, *Happy Reflections*.

Happy Reflections,
sketchbook study

Stages of Development

The inspiration for *Happy Reflections* was a
group of figures standing at the water's edge
and their reflections on the wet sand. This
created an almost *contre-jour* subject (see
page 72), with the figures silhouetted
against the sunlit sea. I made a drawing of
the scene in my sketchbook, as shown
above, and used this as the reference
material for the studio painting.

117

As in this painting, my usual way of starting is to roughly indicate the key elements of the composition – in this case the figures – by drawing with a B pencil on the prepared MDF support. Next I work on the underpainting. For the underpainting in *Happy Reflections* I used a basic mix of yellow oxide and Van Dyke red diluted with gloss glaze medium, working across the whole picture surface but varying the tone in places and so beginning to establish the underlying tones and colours for the finished picture. You will notice in the illustration on the left that I have made the area darker where the figures were sketched in; I have also introduced more yellow oxide to warm up the foreground beach area.

Happy Reflections,
(stage 1)
The underpainting.

The underpainting is made quickly and very loosely, as you can see, and it is left to dry before I begin on the next stage of the painting in which, initially, I concentrate on the most influential part of the subject matter. In *Happy Reflections* this is the source of light, which is the sea area behind the figures. I painted the light as a positive element, and in so doing this replicated its

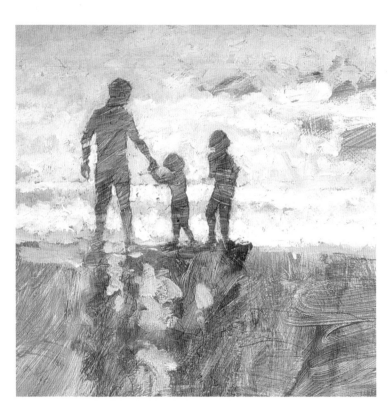

Happy Reflections (detail),
(stage 2)
Developing the centre of interest.

effect in nature, defining and dissolving the edges of the figures in a 'lost and found' way. I was, in effect, creating the shape of the figures on the water's edge by painting the negative space around them.

Once I had blocked in the sea area I worked down across the foreground space and began to consider the interlocking shapes of sand and water. These were painted together, wet against wet, leaving bands of the underpainting to form the reflections. Always my aim for this stage of a painting is to relate the rest of the composition to the starting point, the centre of interest, and to keep everything in the picture developing at the same pace. Now the painting is roughly three-quarters complete.

Happy Reflections,
(stage 3)
Relating the rest of the composition to the centre of interest.

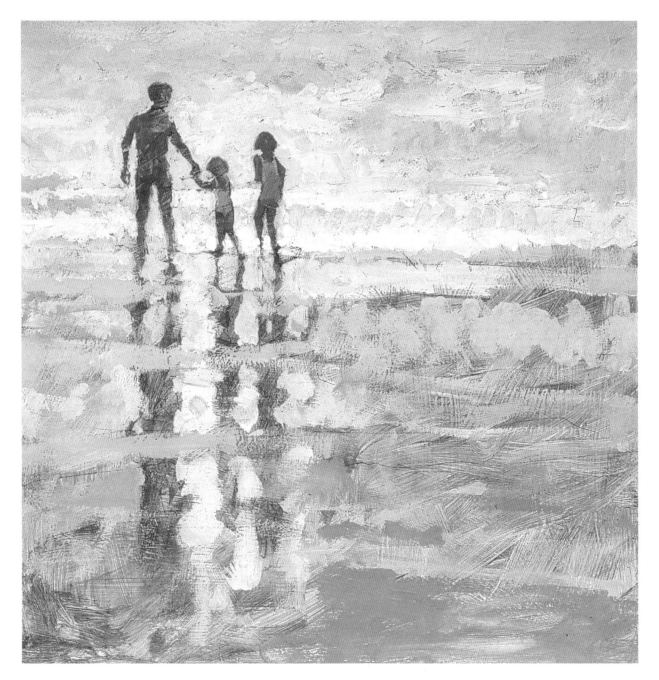

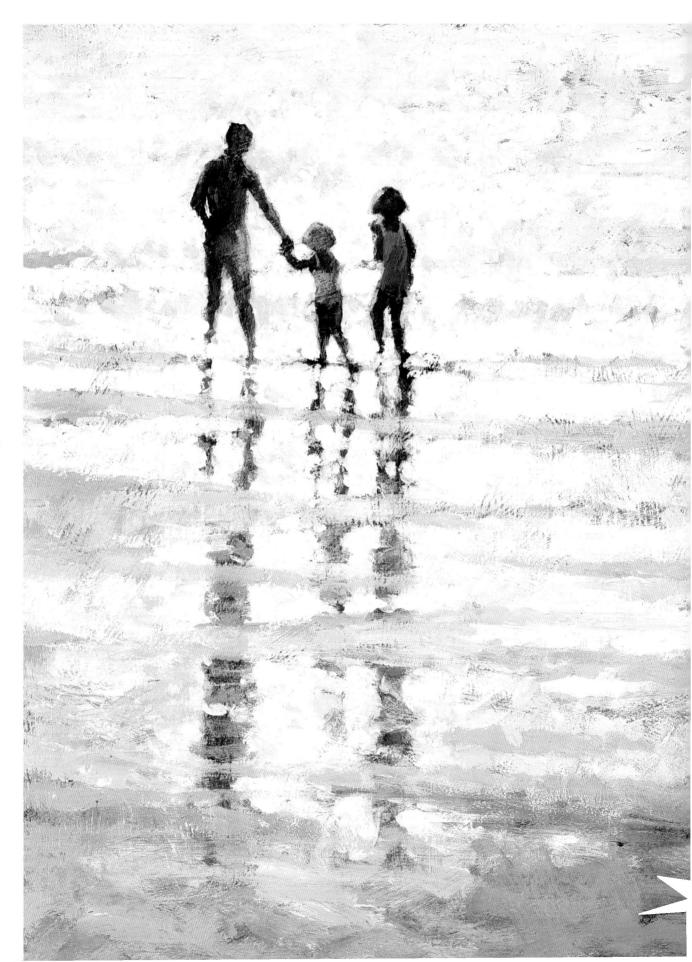

Regularly while I am working I like to stand back from the painting to evaluate progress. Also I check periodically to see how the painting looks in a frame. I have a number of old frames of different types and sizes that I keep in my studio for this purpose. It is surprising how a frame can influence the composition and other aspects of the work. In particular I like to check how the frame affects those elements of the composition that touch or will be cropped by it. I know that the frame will cover a small strip all the way around the edge of the finished painting, and this has to be taken into consideration when making decisions about the composition as a whole.

In the final stage, which is often the most important one, I consider which areas need further attention, whether any colours or light effects ought to be more intense, and whether there are details, highlights and so on that I should put in or rework. In the finished version of *Happy Reflections* (left) you will see that I have added a little more colour to the figures to suggest the bathing costumes and to model the forms slightly (although essentially the colour of the figures is still that of the underpainting); I have also made the sea more vibrant and shimmering. This was achieved by flecking the surface with intermingled touches of white, lemon yellow and light blue – colours that I knew would interact with each other to animate the surface and emphasize its iridescent quality.

Sometimes in this final stage I apply further glazes to enhance the depth and quality of the colour in certain areas, or perhaps to 'warm' or 'cool' the mood of the whole picture. However, such glazes were not required in *Happy Reflections*. Then I leave the painting for a while to give the paint time to settle. A week or so later I check to see whether the paint has dried satisfactorily – there may be dull patches that need attention – and whether there is anything I have missed or which, after a fresh assessment, needs altering. When I am happy with everything and sure that the paint is completely dry, I varnish the painting, as explained on page 44.

121

Happy Reflections.
(stage 4)
30 x 30 cm (12 x 12 in)
The completed painting, with enhanced passages of colour in places and final touches and details.

Freedom and Expression

The process I have outlined for *Happy Reflections* is typical of the way that I work although, as I have explained, no two paintings are ever completed in exactly the same way. Something else that I would like to emphasize is that, in my view, there is far more to painting than acquiring practical skills and developing a sound, and hopefully flexible, studio technique. Such skills are necessary in helping you achieve your aims for a painting, but they are not enough on their own to create exciting pictures. A significant part of painting is about expressing your feelings, and this is both an emotional and an intellectual process.

As you have seen throughout this book, while practical skills are always important, the success and impact of a painting is largely determined by the decisions that are taken at every stage of the work. In making these decisions you have the freedom to interpret in your own, individual way the particular qualities and features in the subject matter that most impress and inspire you. This is what makes the painting yours, what makes it original. I think that if you are able to communicate those thoughts and feelings successfully and stimulate a response from other people viewing the work, then that is the mark of a good painting.

Sereno, Venice,
60 x 57 cm (23¹/₂ x 22¹/₂ in)
Passages of heavily layered impasto and glazes take on an almost abstract quality in this painting, which I hope conveys the sheer joy of applying paint.

Flowing to the Sea,
60 x 70 cm (23¹/₂ x 27¹/₂ in)
I approached this painting with great enthusiasm and spontaneity, working quickly to establish rhythms and patterns within the composition, building to a richly textured surface.

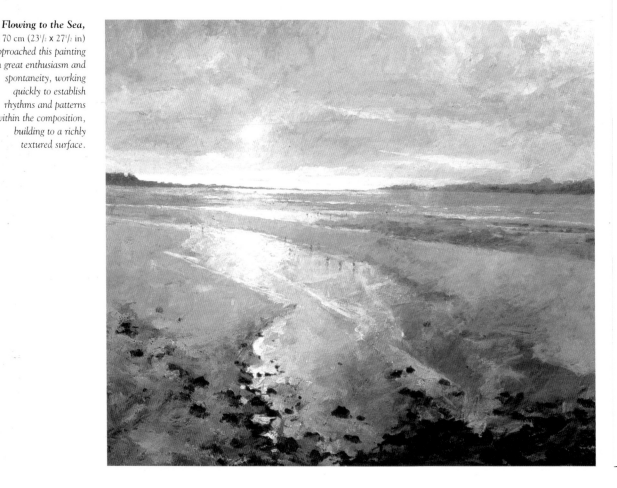

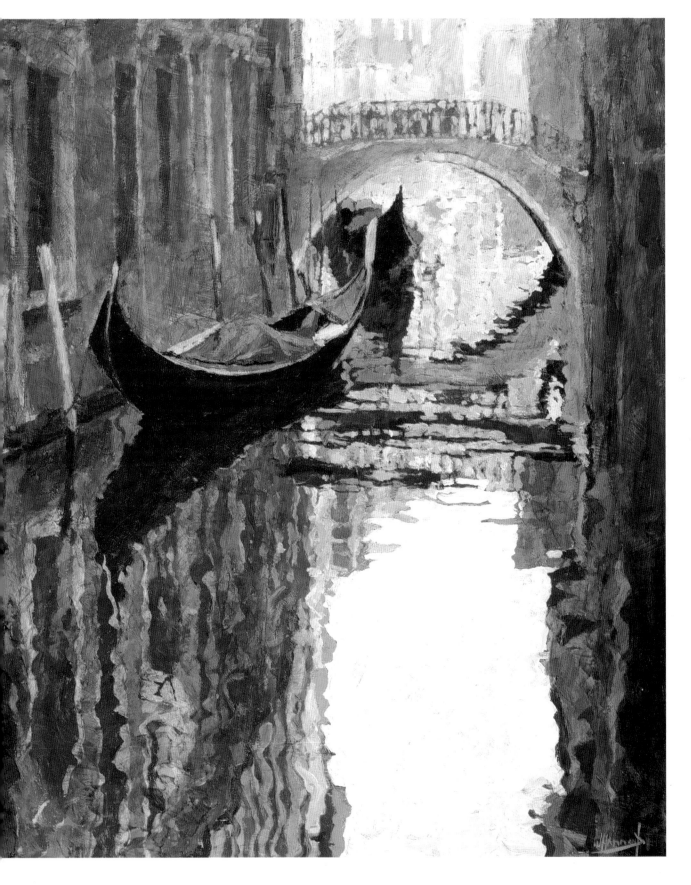

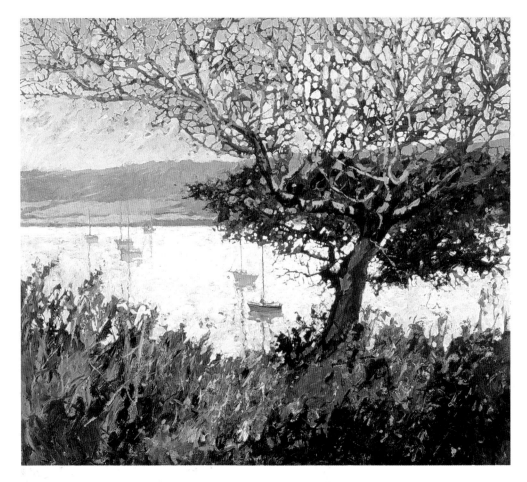

Noss Mayo II,
90 x 80 cm (35¹/₂ x 31¹/₂ in)
*A crisp winter sky
breaking through the
skeletal tracery of branches
highlights the rich golds and
reds of the bracken and
undergrowth in this south
Devon scene. This is in
contrast to the flat, silver
light that shines from the
estuary beyond.*

124

**Shifting Sands,
Devon Beach,**
30 x 30 cm (12 x 12 in)
*Working with speed to
capture the movement of a
quickly ebbing tide as it
formed rippling patterns in
the wet sand, I was
looking to create an
impression of that
moment, rather than a
highly resolved but static
representation.*

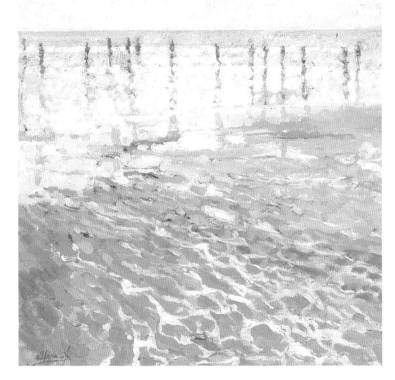

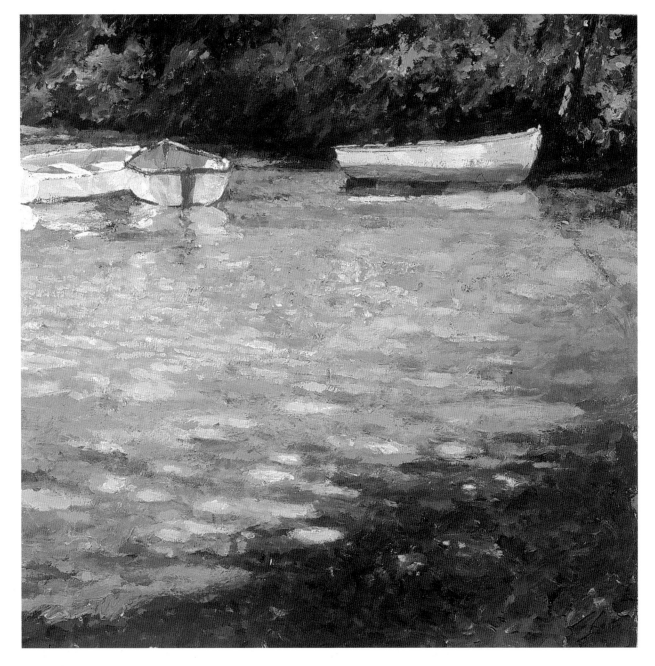

Golden Dapple,
40 x 40 cm (15¹/₂ x 15¹/₂ in)
This atmospheric painting,
which uses layers of colour
and glazes to give texture
and depth, brings back
memories of a perfect
afternoon by the river.

126

Iris Field, Chianti,
80 x 90 cm (31¹/₂ x 35¹/₂ in)
*Some views seem to have
been created just to be
painted! Here, the rich
colours of the iris flowers
are balanced by delicate
touches of similar hues in
the olive tree foliage.*

INDEX

Numbers in *italics* refer to illustrations